Kurelek Country

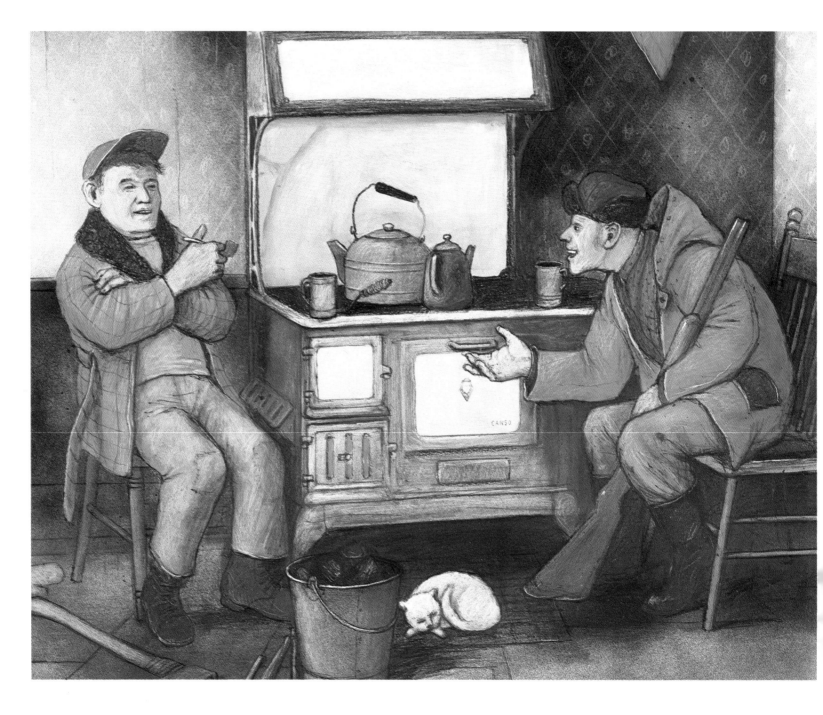

Kurelek Country

William Kurelek

HOUGHTON MIFFLIN COMPANY • BOSTON
1975

Library of Congress Cataloging in Publication Data

Kurelek, William, 1927-
 Kurelek country.

 1. Kurelek, William, 1927- 2. Canada in
art. I. Title.
ND249.K85A49 1975 759.11 75-17697
ISBN 0-395-21971-X

10 9 8 7 6 5 4 3 2 1

Printed and bound in Canada

To my wife, Jean,
the beautiful, charming Canadian woman,
who contributed to my experience of some of the joys
recorded in this book.

Acknowledgements

I always like to give credit where it is due but in the case of this book its scope makes adequate acknowledgement difficult. To begin with, the paintings came first and the book idea followed. There were many sources from which I derived information and inspiration; my uncle George and cousin Dmytro in British Columbia, and Terry Ryan in Cape Dorset, for example; or such books as *Nova Scotia*: *Window on the Sea* and *Canada, A Year of the Land.* These and others were rightly acknowledged at the showing of the paintings in this book at The Isaacs Gallery in Toronto, under the theme, *The Happy Canadian.*

My thanks are also extended to Beverley Slopen who assisted me in the research and writing of the text.

Contents

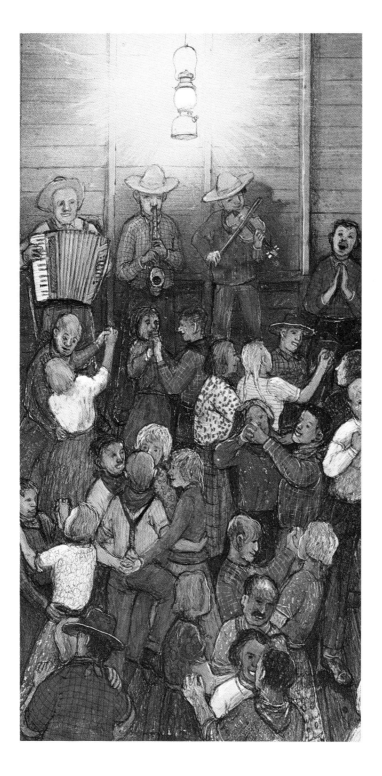

Foreword

Canada is the setting for the pictures in this book. It is a country too vast and varied for me to present a comprehensive view but I hope I have managed to evoke the mood of the main regions. The theme of the book is Joy. It is my view of joy, both remembered and observed, in this my native land.

As I saw it, a single joy did not equal happiness, nor did several joys add up to happiness. I have depicted moments of joy such as those that occur when we are at leisure, for example, in the paintings "Skating on Spring Run Off" or "Fish Fry at Middle Cove." On the other hand, sometimes joy is the exhilaration of relief from discomfort. "Newfie Woodsman Doffing Rainwear" represents that. Or it could be the satisfaction of creativity, as in "Woodcarver's Family." Or the pleasure of social life such as in "Barn Dance" or "Neighbourly Visit." Occasionally joy comes from the discovery of God's gifts—note "Oil Strike in Peace River Country." Or from a successful gamble with Nature, reflected in the farmer's face in "Bumper Harvest." Many people imagine they would be happier not having to work for a living, but there are some, as in "Hutterites Happy with Good Day's Work Done" who do exalt honest toil. I ought to add also that although the majority of North Americans are city dwellers, I have deliberately chosen rural rather than urban settings. It is usually close to Nature that the simplest, most elemental pleasures are found.

When I survey the whole question of joy compared to happiness, I find I have my conversion to Catholicism to thank for a right understanding of it. God scatters all kinds of individual joys and pleasures before Man. But the scene is rather like that of children in a field of wild flowers. Picked or not picked, flowers (and youth too) will wilt, fade, grow old, and pass away.

True and lasting happiness can only be found in union with God, the source of all joys. We live in this world for a brief span of some seventy years, but in the next world, forever.

Nevertheless, although I do not consider Canadian citizenship nearly as important as citizenship in the Kingdom of Heaven, I am proud of being a Canadian, just as I am of my Ukrainian ancestry. There was a time during my boyhood in Manitoba when I used to feel the call of the great, free, flat bogland to the east of our farm. I found myself walking or cycling out to it whenever freed from farm work. Although my father didn't own a single foot of the bog, it still said to me, "You and I belong to each other." When I grew up, I travelled through many countries. I even lived happily in England for seven years and almost settled there permanently. But in the end I returned to Canada. And although I still see disturbing things here which I will continue to protest, I am happy to be home. I hope this book proves it.

Newfoundland

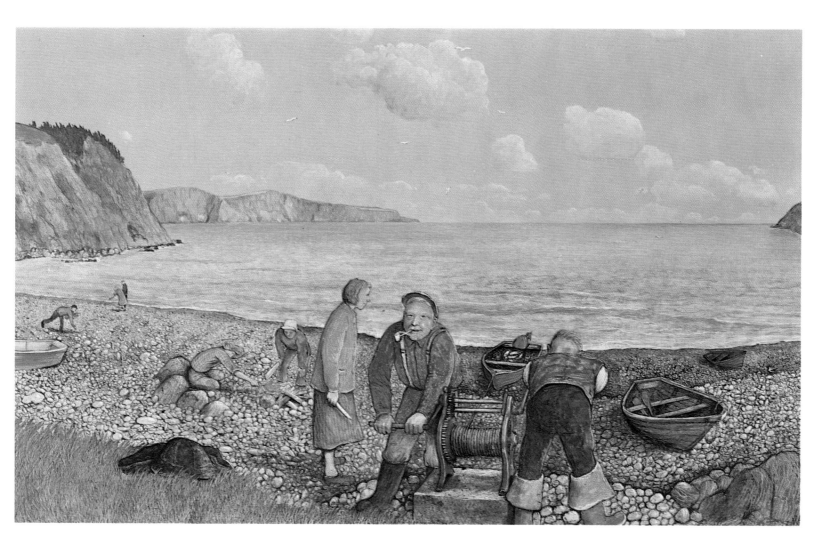

Fish Fry at Middle Cove

I landed at the Port aux Basques ferry terminal in the very early morning. My first glimpse of Newfoundland was the rocky shore where the Basque fishermen once came to dry their catch before sailing home. My destination was the province's capital, St. John's, where a hotel room would serve as my painting studio for the next two weeks. It was clear and bright, and during the all-day bus journey some 650 miles to the far side of the island, I was able to study the terrain. At first there was only rock and very scrubby, wind-shaped pine. Later, between Corner Brook and Gander, there was a very healthy-looking evergreen forest.

It was late evening when I arrived in St. John's. The next morning when I peered out the window of my downtown hotel room, I could see rows of flat-roofed, garishly painted clapboard houses, some clinging to rock faces, and hardly a tree in sight. Below was the harbour with ships moored at their piers and, crowning the scene, was the rocky promontory of the famous Signal Hill where the first trans-Atlantic wireless message was transmitted in 1901 by Marconi, and many others after that. Signal Hill was hidden from view by the notorious Newfoundland rain which consists of very fine droplets that fall rather than hang suspended as in a mist. I named it "Soaker."

After nine intensive but happy days of painting, cooped up in that little hotel room, I just had to see a Newfoundland farm. I was raised on the land in Manitoba and the farm still calls me back. But I also wanted to get closer to the sea. Figuring that I might be able to have it both ways by driving out of town through the countryside to the nearest beach, I approached a taxi driver parked in front of the Newfoundland Hotel. He hesitated at what seemed to be an unusual request. "That's about fifteen miles away," he replied. "Suits me fine." As we drove, I studied the map. Newfie place names are a delight, as

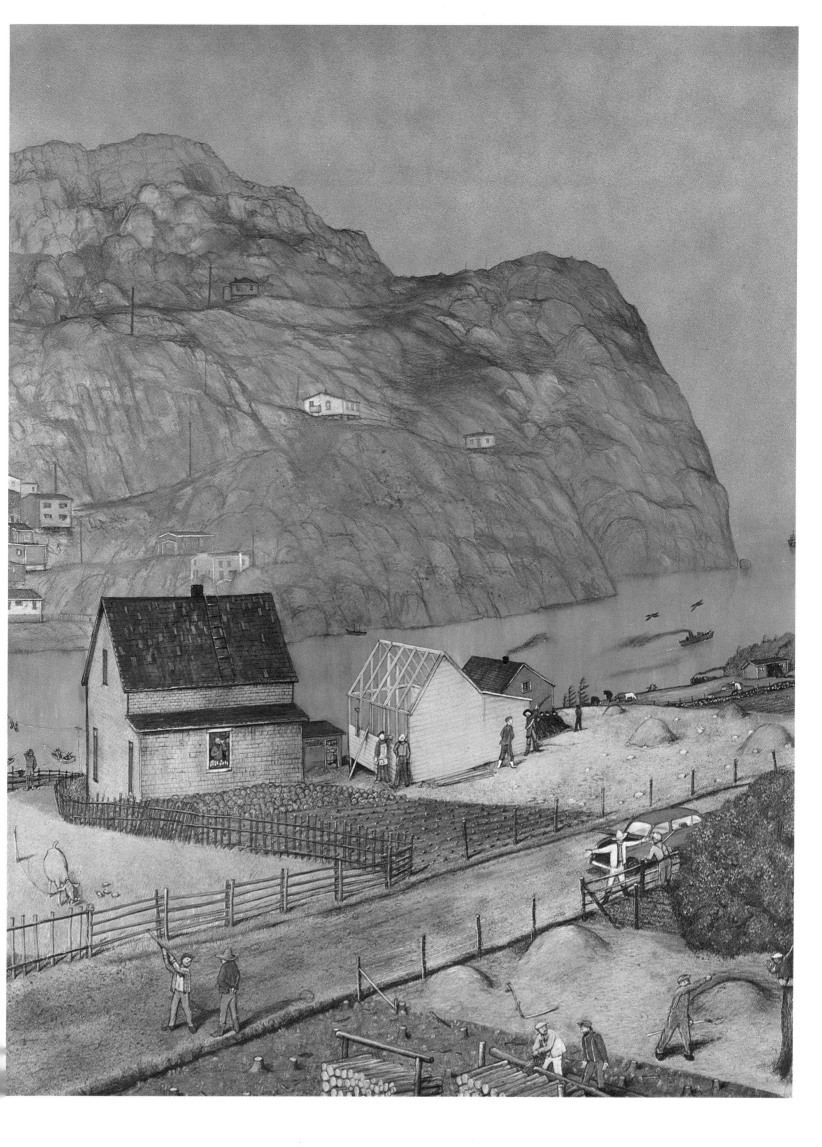

if they had been coined in a more imaginative age. Come-by-Chance, Witlers Bay, Butter Pot, Hearts Content, Mings Bight, Lon Har, Annieopsquotch Mountains, and the like. The map also showed, of course, Cape Bonavista where John Cabot first landed in the New World in 1497. His reward: ten pounds sterling from his king.

The cab let me off at Middle Cove. Below me, I noticed two fishermen in hip waders pushing a boat down to the water from a dilapidated boathouse. I threaded my way down the cliff to chat to them. "Is this really the end of Canada?" "Yep, that water's the Atlantic—stretches clear to Europe."

Still more interested in soil than sea, I walked inland, photographing small dairy and potato farms. The land seemed too rocky and rained on for grain growing. Eventually, I decided the cove was more representative of Newfoundland and returned to study it in detail.

The beach is not sandy or even pebbly, but bouldery—if there is such a word. Each wave strikes these smooth stones, the size of bowling balls, lifts them onto the shore, and then abandons them to go clattering loudly back down to the water. A walk over a field of these stones gets one's ankles well exercised. Here and there I could see blackened areas—the sites of old campfires made from the plentiful supply of driftwood scattered about the beach. The pleasures of picnicking are widely known, and the Newfoundland version might be a fish fry on the beach. The menfolk put out in a boat to catch the fish, while the women and children prepare the fire. On their return, the men windlass the boat up the cobbled shore, as I have depicted in the painting.

If anything of Newfoundland culture is known to outsiders, it is likely to be the Newfie joke. Exuberant and corny, it usually pokes fun at the stupidity and literalness of either fellow Newfoundlanders or such favourite targets as Americans, Torontonians, and Nova Scotians.

Sample:
How do you get ten Newfies into a Volkswagen?
Tell them you're going to Toronto.

Or:
Who has an I.Q. of 174?
174 Nova Scotians.

Or:
The only reason Newfie jokes are so simple is because we want mainlanders to understand them.

And that warning to outsiders:
What is black and blue and floats in the bay?
A mainlander after telling a Newfie joke.

It is often the humour of the poor and struggling, a laughter born of a hazardous life in a rocky, misty land. To capture their irrepressible spirit, I have depicted an imaginative setting combining various elements of Newfoundland countryside and way of life—steep cliffs, the changeable sea, small farms, and hard-working people—and encircled it with fifteen Newfie jokes (leaving out the suggestive, salacious, or tasteless ones). It is a hard life, sometimes a grim life, but jokes provide a form of relief.

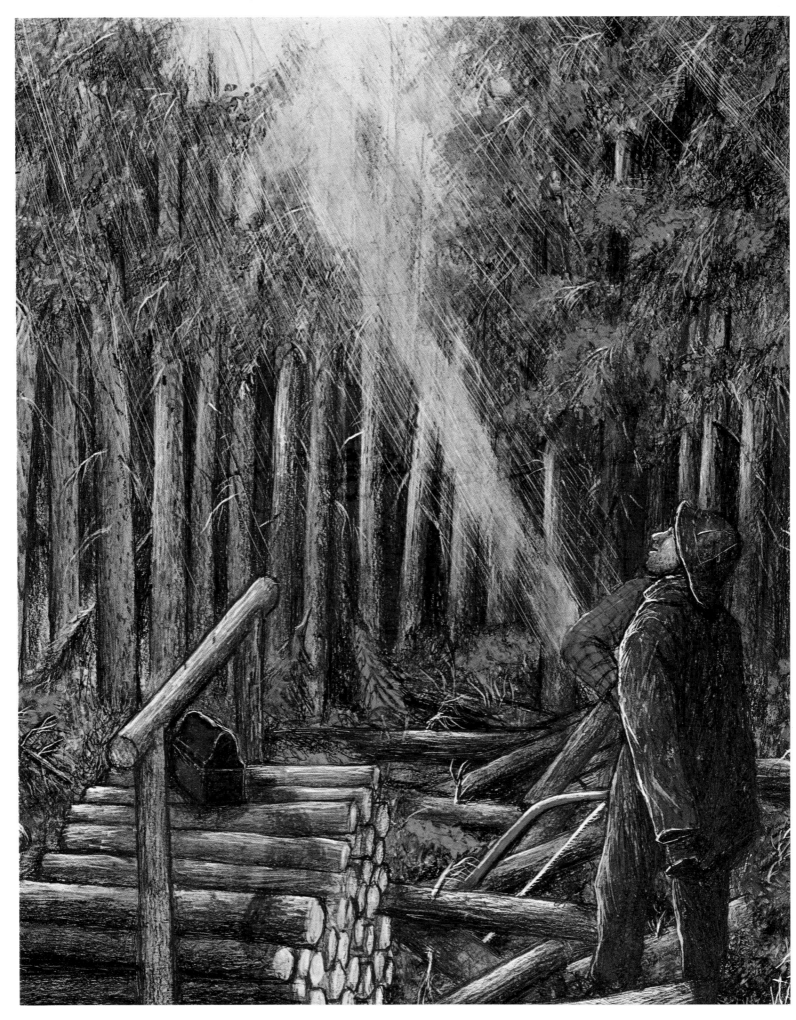

Newfie Woodsman Doffing Rainwear

Traditionally, Newfoundlanders have been cod fishermen. Now, fishing has ceded first place in the island's economy to the growing pulp and paper industry. Many men work at both. But the frequent rains mean that if they want to make ends meet, they have to keep on cutting during the Newfoundland soakers. For protection they wear the same rubber clothes that protect them from the ocean spray while fishing. Although I have never worked in the Newfoundland forests, I did work as a lumberjack in Ontario and Quebec. I believe I know what it is like to be a Newfoundland pulpwood cutter. Where I worked, the other woodsmen gave up during a downpour and returned to camp to play cards, but I bought a rubber rain outfit and set myself a twelve-hour a day work schedule, rain or shine. At the time, it was the only way I could make enough money to get to Europe and continue my art studies. Rubber is clumsy and sweaty if you are working hard. One of the simplest joys comes when the sun finally breaks through the clouds and you can doff that rainwear and enjoy the relief of getting aired and cooled off.

Nova Scotia

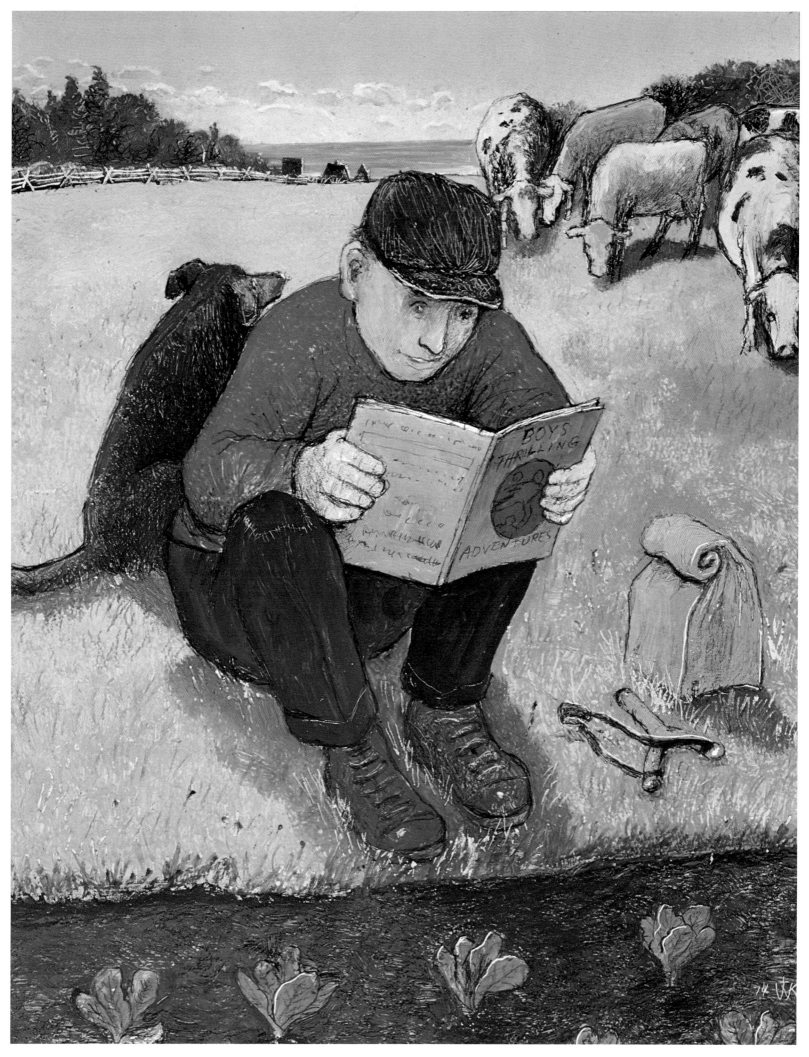

Cowherd Enjoying Adventure Thriller

My first visit to Nova Scotia was during the winter. I was holed up in the mining and steel towns of Sydney and Glace Bay on Cape Breton Island. At the time I was interested in gathering information about the early Ukrainian settlers in the area. There have been three waves of Ukrainian immigrations to Canada. On their arrival in Halifax from Europe before World War I, a small number of the earliest group were diverted from their destinations in the prairie provinces and hired to work in the steel mills of Sydney. The settlers in Glace Bay were brought in before World War II from Northern Ontario mining towns, such as Timmins and Kapuskasing, to work in the coal mines. At first I mistakenly thought that the two communities huddled together and that they were too poor to commute the twelve or so miles from Sydney to Glace Bay except on foot. To recreate that experience I myself walked the distance one grey, winter day.

To be truthful, I found Cape Breton Island to be as bleak and depressing in winter as the early French soldiers found it when they were sent to the island in the 1700's to man the fort at Louisbourg. It was the loneliest, foggiest outpost in North America. Later that year, in summer, I travelled through by bus, and saw the more beautiful aspects of the province. I feel closer to a place when I travel by bus. It makes frequent stops and follows the contour of the land. Travellers have to sit close, tight against each other. Travelling by train or plane you skim over the surface. We rode through much green pasture land and, from talking to Maritime friends who were once farm boys like me, I found that my childhood experiences were not unique to the prairies. Here were the same cruel practical jokes, the local superstitions, the farmyard accidents, the rough, tough, one-room schoolhouse education, the cowboy music culture. The

inter-lake farm country north of Tuelon, Manitoba, where I lived as a boy was more suited to dairying and mixed farming as practised in Nova Scotia than for growing grain, and I could easily project myself into the Maritime countryside, pasturing cows at the edge of a vegetable truck garden. In the painting, the boy is engrossed in an adventure thriller, just as I used to be. In those days, we read comics like Tom Mix, Bronco Bill, and Lone Ranger, and pulpy western novels where cowboy heroes with phenomenal stamina led far more action-packed lives than we cowherds who tended a few peacefully grazing cattle. The big difference is that nowhere in Nova Scotia is the sea far away. It is a small peninsula, but its indented shores give it a coastline five-thousand miles long, farther than from Halifax to Victoria, British Columbia. I did not see a large body of water—in my case, a lake—until I was sixteen years old and we got our first car, making it possible to visit Winnipeg Beach.

Sunday Dinner Call in the Bush

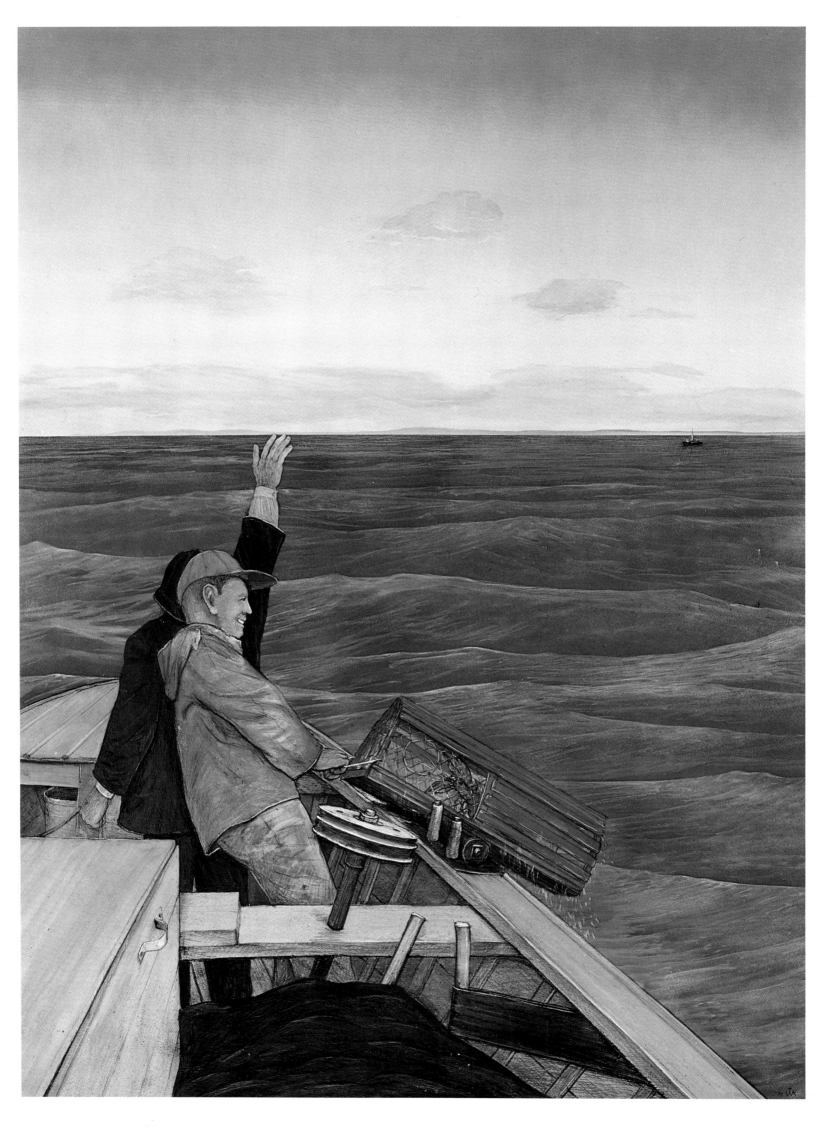

My experience of the Atlantic Ocean comes from crossing it. I have made four voyages to and from England, the first in 1952 when I travelled by tramp steamer for three long, halting weeks to Wales. My only preparation for such a sea voyage had been my Latin classes at high school and university where I was told that reading Homer's *Iliad* gives the same awesome feeling as crossing the ocean for the first time. Well, not for me. No awe whatever. Only terror. And a concern for holding down the meals I shared with the ship's officers.

Prairie farmers used to feel a similar terror before the days of all our modern communications, like cars, phones, and radios. I knew if I fell overboard, I would be a goner, just as I knew in the old days that if the farm buildings went up in flames and I had to run out into the snow at forty degrees below zero in my underwear, I would be a goner. To me the expanse of the sea gave the same feeling as the prairie in winter when the landscape is an endless series of wind-sculpted snowdrifts, punctuated only by the flimsy march of barbed wire fence posts.

I do not know if Nova Scotian fisherfolk in their boats get that same sense of human helplessness in the huge rolling mass of sea water under and all around them. I am sure in storms they do. Therefore, when I wanted to represent the joy of a Nova Scotian fisherman, it was not the joy of a full lobster trap (however important that might be) but the simple, elemental pleasure of recognizing an acquaintance's boat across the water at dawn. I imagine one of them saying to his buddy as he instinctively raises his arm to wave, "Say, that's the McPherson outfit!" or words to that effect. The feeling is somewhat akin to the warm glow a prairie farmer gets from seeing a far-off neighbour's farmhouse lights come on in the evenings.

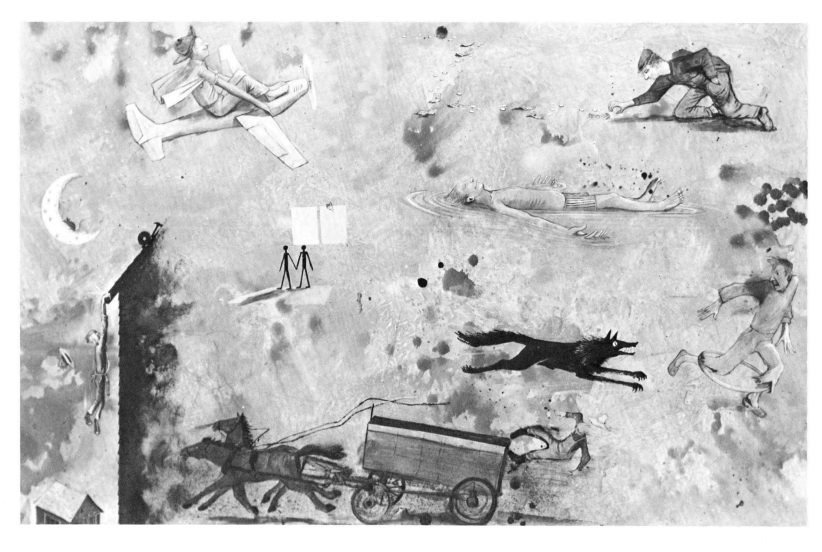

Farm Boy's Dreams

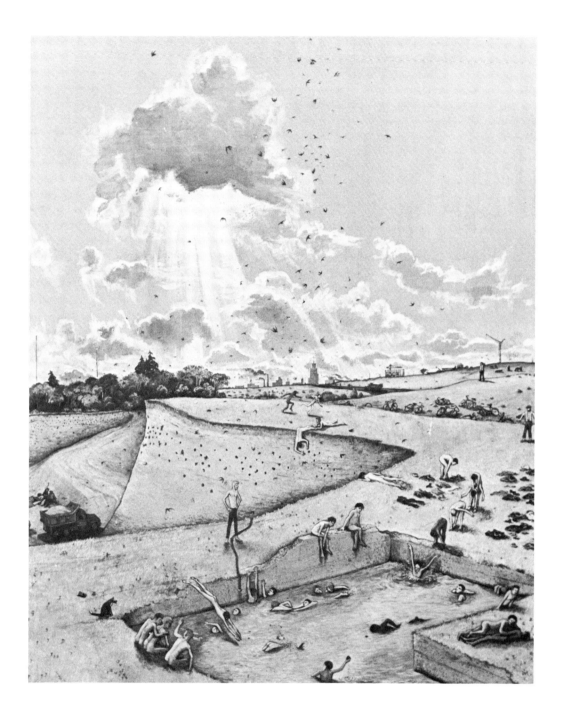

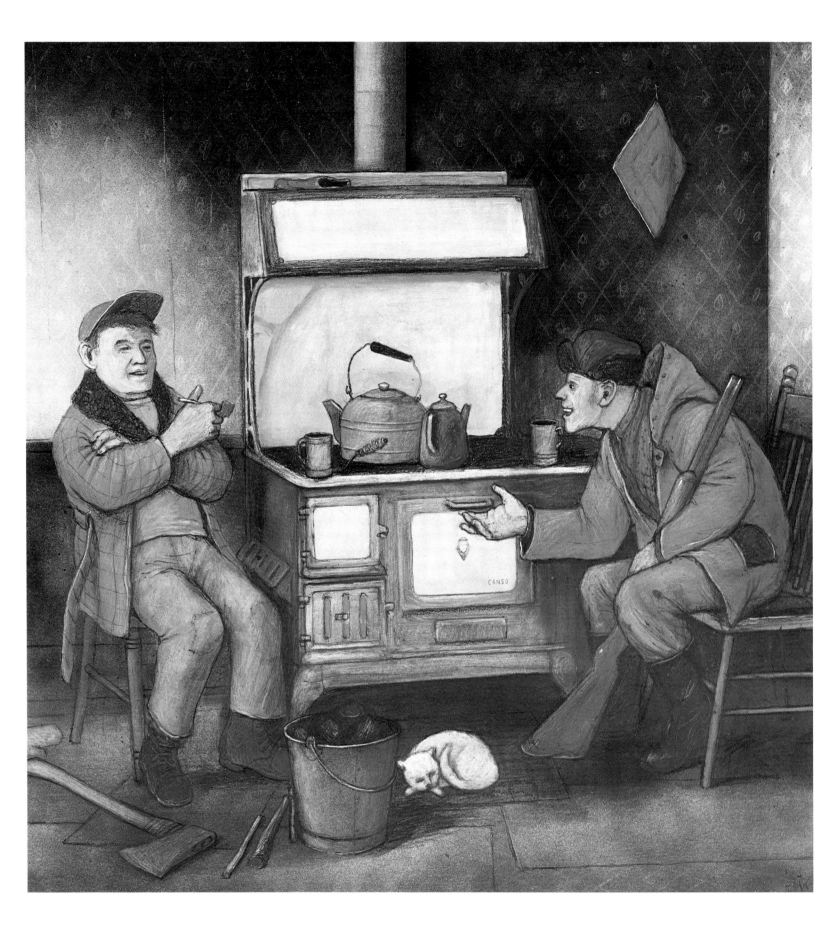

In the book, *Nova Scotia: Window on the Sea* by Ernest Buckler and Hans Weber, there is a striking black and white photograph of a man sitting at a coal-and-wood burning kitchen stove. That stove is similar to the ones we used out West to heat farm kitchens. It was often the only warm room in the house and we all gathered there. I have painted the man in that photograph but I have given him company—another man and a cozy cat. The mood is one of easy relaxation: a cup of coffee or tea beside a quietly singing kettle during a mid-morning break in winter. Out West, people used to drop in unannounced to exchange bits of farm news and spin yarns. To my boyish eyes, at least, it always seemed like a welcome interruption.

If the atmosphere seems shabby or run down, it is because these people are not rich. The visitor is carrying a rifle—he has been out rabbit shooting in an attempt to thicken the stew pot. Traditionally, the Maritimes have been the most economically depressed region of Canada and many people may not have the resources for more elaborate entertainments. But then, nothing is quite so warming and enjoyable as a fireside chat with an old crony.

New Brunswick

New Brunswick Potato Diggers Enjoying Autumn Colour

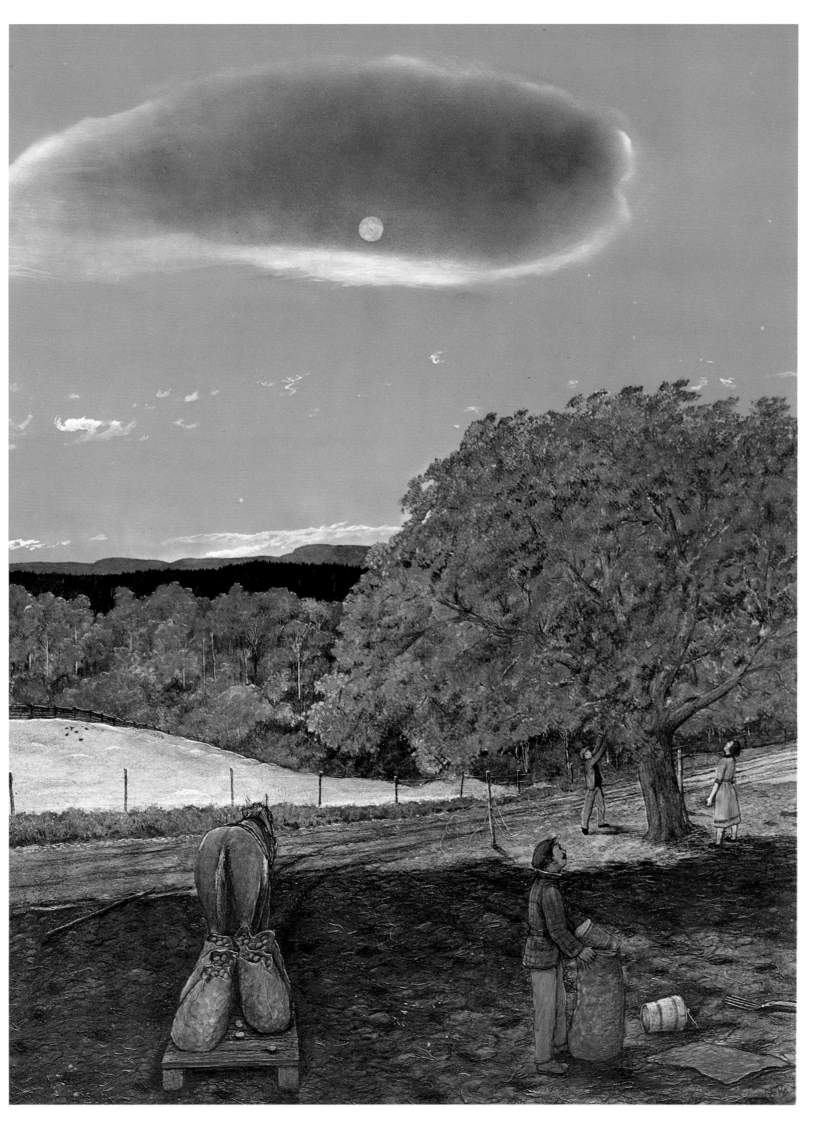

When I lived in the West, I could not understand why the maple leaf had been chosen as Canada's emblem. Come fall, there were only white poplars turning off-yellow, or oak leaves becoming drab brown. Even after we moved to Ontario's Niagara Peninsula where every second tree on my father's land was a maple, I did not see the celebrated vibrant colour because the balmy fall air there lacked the necessary tang or sharpness. Then I visited northern Ontario in the fall and it hit me: all those rich reds, oranges, and yellows. I could not get over the wonder of it. New Brunswick also becomes aflame with a joyful riot of colour, every bend in the road offering another feast for the eyes. If the day is grey or the sun is briefly hidden by a cloud, as in this painting, it only emphasizes the vividness of the colours.

The beauty of the fall might also make potato picking in New Brunswick less arduous, at least in my imagination. In the West, potato picking was often a grim, grey time. You could feel the freeze gripping the ground even as you dug. The few yellow and brown leaves blew up and down the garden rows in the chill winds, all of which imparted a sense of urgency. I know that potatoes are a major commodity in New Brunswick, along with lumber and fishing, and that potato pickers may not always work at the leisurely pace I have depicted in this scene. There is a popular New Brunswick folk song which has a rather ominous note. It goes:

How are your potatoes?
Very small.
How do you eat them?
Skin and all!

But on lovely fall days when the trees are most vivid, workers might relax more and drink in the beauty of the Creator's artistry.

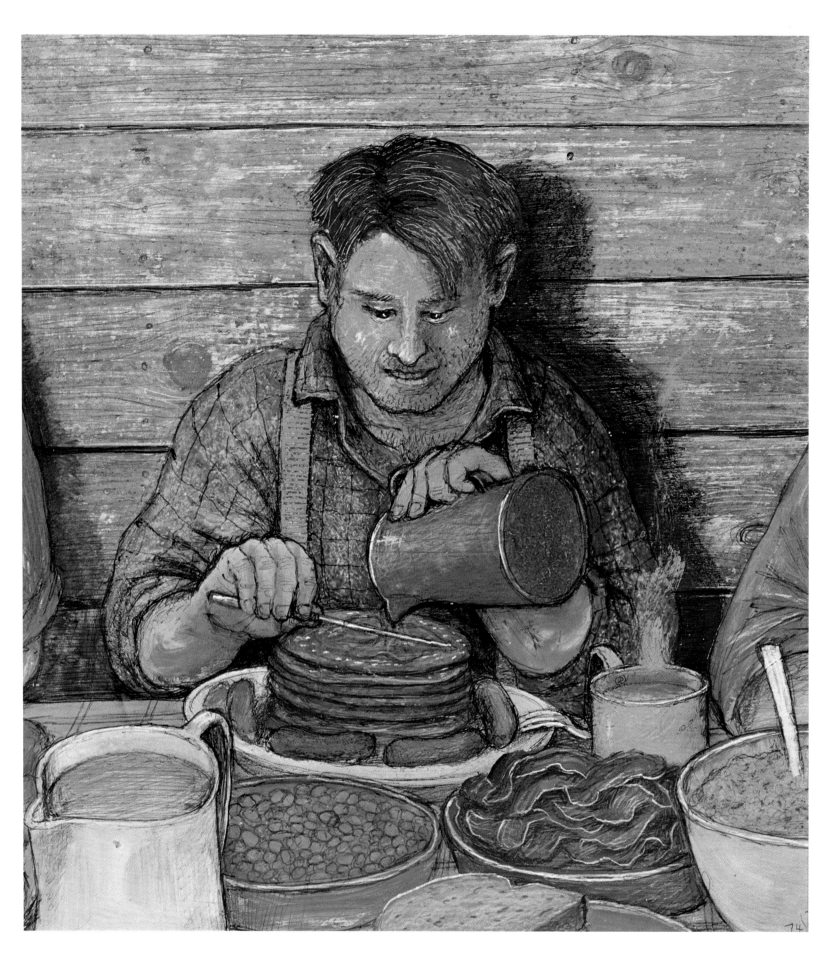

Bûcheron Enjoying Breakfast

New Brunswick has always had a lumber industry, and a substantial French population going back more than two hundred years to the days of the Acadians. Seeing those New Brunswick forests during my two journeys through the province, I could not help but think of my own experiences as a pulpwood cutter in Ontario and identify with a New Brunswick lumberjack, or *bûcheron* as he is called in French.

When I think of those days in the bush, I am reminded of the joy of a hefty meal that comes from having an appetite. And lumberjacks sure have it. They attack their food with gusto and they do not need to worry about over-indulgence. I used to eat three times as much as in the city, but calories are all burnt up in exercise and fresh air. At that time in 1951, we paid only $1.25 a week for room and all we could eat. The wake-up gong was sounded by the "cookee" (the cook's helper). Another gong twenty minutes later said, in effect, "Food's on! Come and get it!" Everyone, dressed or partly dressed, rushed toward those wooden benches around the oilcloth-covered trestle table loaded with food: fried potatoes, sausages, flapjacks, fried bologna, bacon, porridge, dry cereals, tea, coffee, canned milk, fried eggs, boiled eggs, omelettes, french toast, and ordinary toast. No one spoke much—just the occasional call for refills amid the clatter of cutlery and dishes. Everyone was too busy devouring the food to make small talk. Here, I have presented a *bûcheron* drooling over the stack of pancakes he will soon demolish.

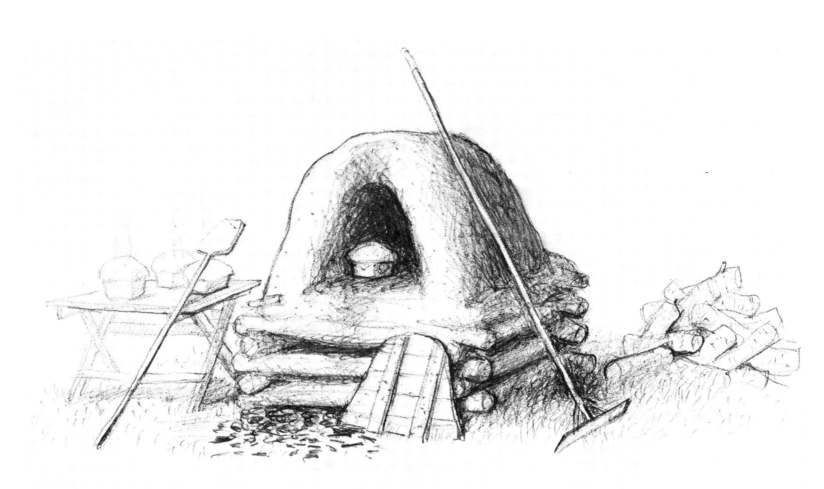

An Outdoor Bake Oven in Operation

New Brunswick is a small province filled with romance and contrasts. Looking at the gentle picture of spring along the shore of the Saint John River, it might be hard to believe that just a short distance away on the island of Saint Croix in the Bay of Fundy, Samuel de Champlain watched thirty-five of his seventy-nine men struggle against the winter and die in 1604.

For New Brunswick, known for its many small rivers, quiet market towns, and rich farms, I wanted to show fresh new life— the willow tree putting out dainty foliage and drinking at the stream waters swollen by the spring thaw. Children, happy to be out of their heavy, restrictive winter clothing, even shed shoes and socks on this first really warm day so that they can feel the soft green grass. They play volleyball and, although I was no athlete, I have felt that same exhilaration as the boy in the white shirt at putting a wicked spiked shot over the net, or the even greater elation of a sensational save. The warm sun has brought out the first fisherman of the season and a couple out for a stroll with their baby. Spring is my favourite time of year for it symbolizes new life and youth. And though I knew a lot of unhappiness in my boyhood, still there are some memories of that time which bring back "joy that is almost pain." As the American poet, Longfellow, put it:

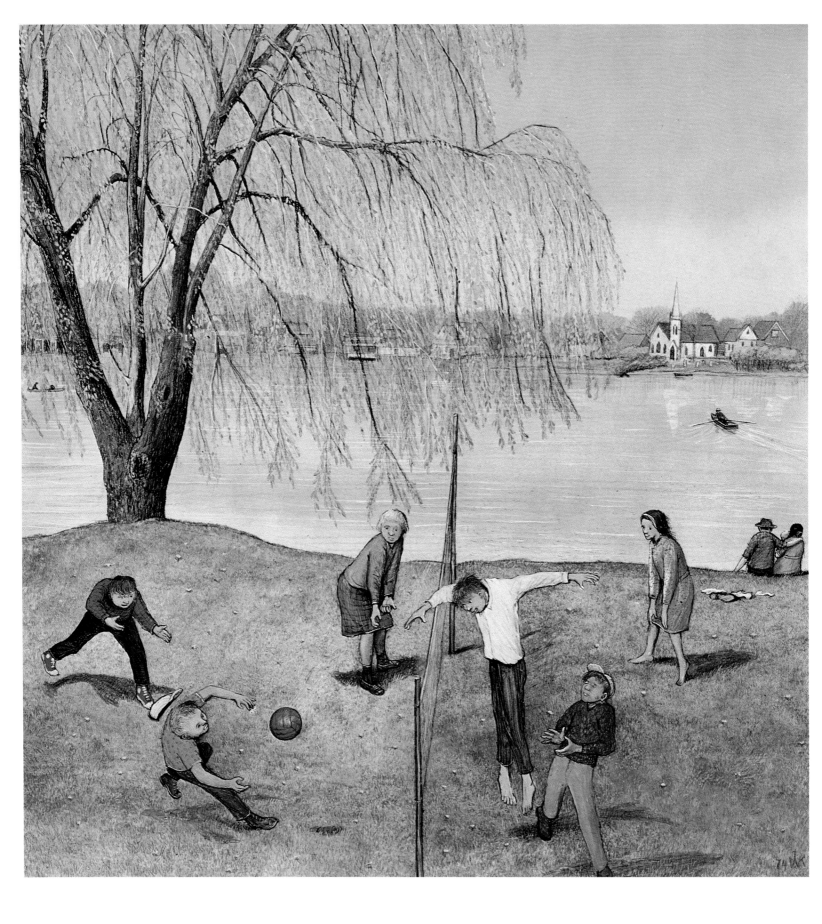

Spring on the Saint John River at Fredericton

"And Deering's woods are fresh and fair
And with joy that is almost pain
My heart goes back to wander there
And among the dreams of the days that were
I find my lost youth again."

Prince Edward Island

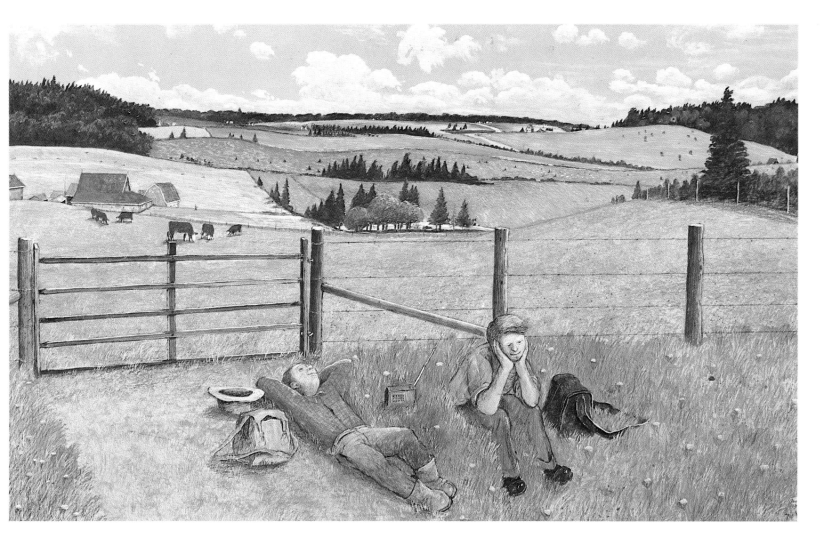

Pastoral Symphony

Pastoral Symphony shows an actual scene near the Hunter River on Prince Edward Island. I saw plenty of such charming settings during my travels through the tiny province. Almost everyone who visits the island falls in love with it, creating a rather serious problem. Non-residents have been buying up land, mainly for vacation property, and there is a concern that a great proportion of the territory will belong to people who are absent and who have no stake in its institutions or its future.

Each summer, thousands of vacationers cross by ferry at Wood Islands or Port Borden and I imagine that these two young hikers in the picture are students who have made their way across the country to Prince Edward Island, lured by accounts of sandy beaches and idyllic pastoral scenes. I have imagined that the music emanating from their transistor radio is not rock or country-western like Hank Snow or Stompin' Tom Connors but Beethoven or Vivaldi. It is unlikely, I know, but for me there is no other music so sensitive to the moods of nature and so suited to the celebration of the Prince Edward Island countryside.

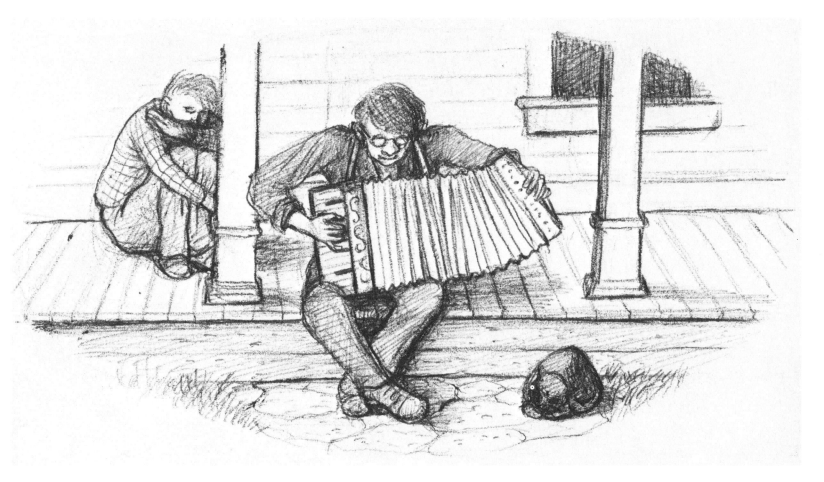

I Was Enthralled by Billie's Playing 51

I felt that I knew Prince Edward Island long before I made my first journey there. My friend, Emmett Maddix, whom I met when we worked together as picture framers at The Isaacs Gallery in Toronto, used to talk about his several-visits-a-year back home to the farm in P.E.I. He comes from a large French-Irish family and big families are often close knit. (Besides, Emmett was his mother's favourite; they are shown embracing in *Homecoming*.) I had illustrated some of his adventures and even did a painting from a photograph of their farm, which Emmett gave his parents. There was no way I could go to Prince Edward Island without calling at the Maddix farm.

After arriving at Summerside by bus, I rented a car and drove in the direction of Miscouche. Everyone knows everyone else in a farming community so, if you keep asking, sooner or later you will find the place you are looking for. The elder Maddixes received me as one of their own, fed me, and even put me up. There on the kitchen wall was the painting I had done for Emmett, only in real life the roof is now green where it had once been red. Joe Maddix and I stopped in for a prayer at the parish church where the cemetery has gravestones for the Maddix family going back almost a hundred and fifty years. We also visited the local museum which commemorates the original French settlement when Prince Edward Island was known as Isle St. Jean and provided food for the garrison at Louisbourg on Cape Breton Island. After it was taken by the British, St. John Island was renamed Prince Edward Island in 1799. I also visited Charlottetown, the capital, and its museum commemorating the historic meeting in 1864 when delegates assembled to establish the basis for Confederation of the British North American colonies, later to be called Canada.

Homecoming to P.E.I.

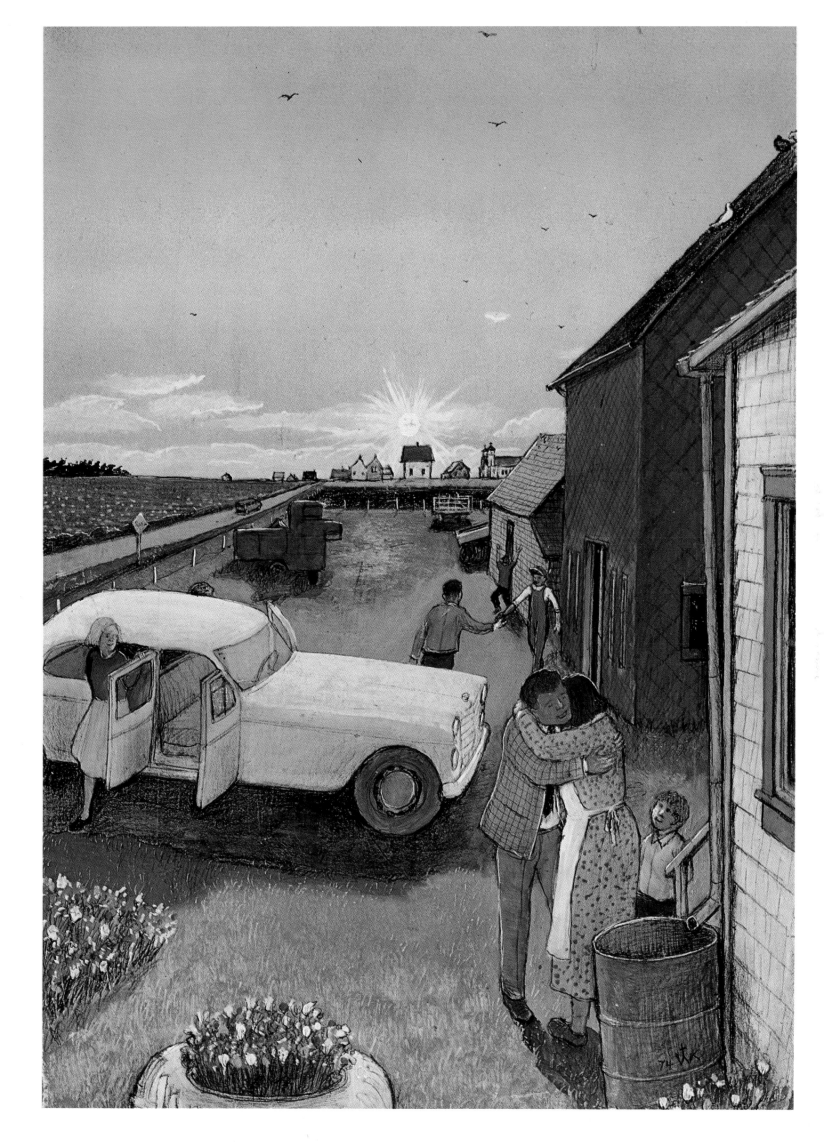

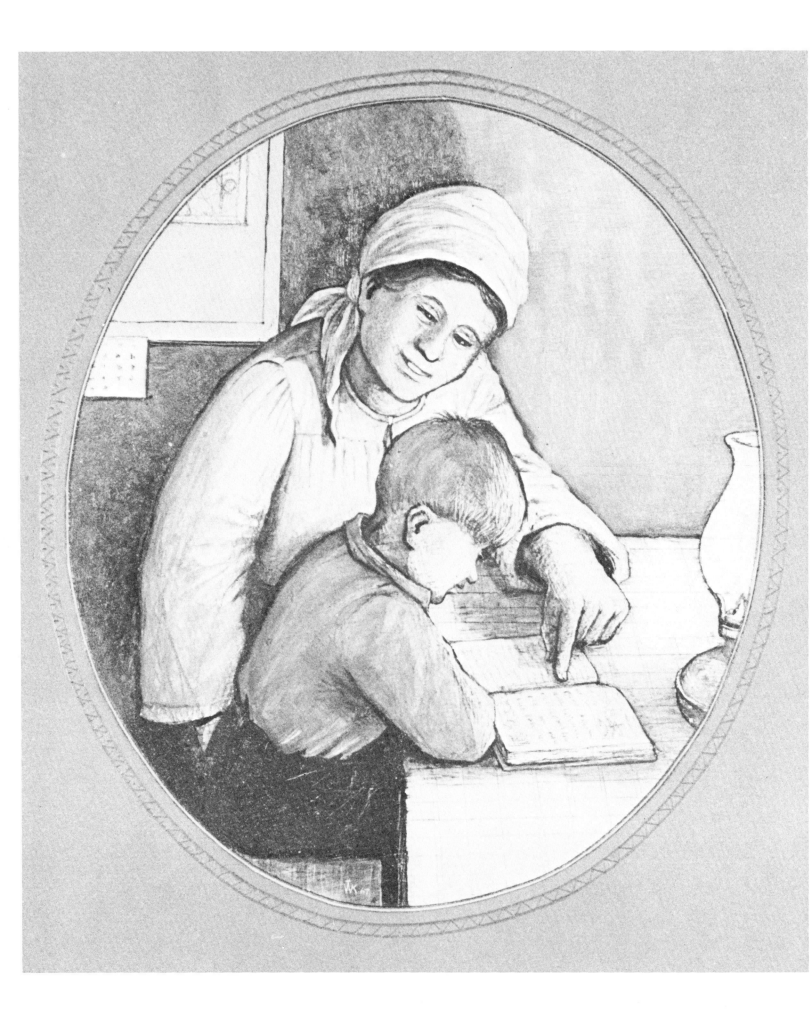

I Also Felt More at Ease in the Novelty Races

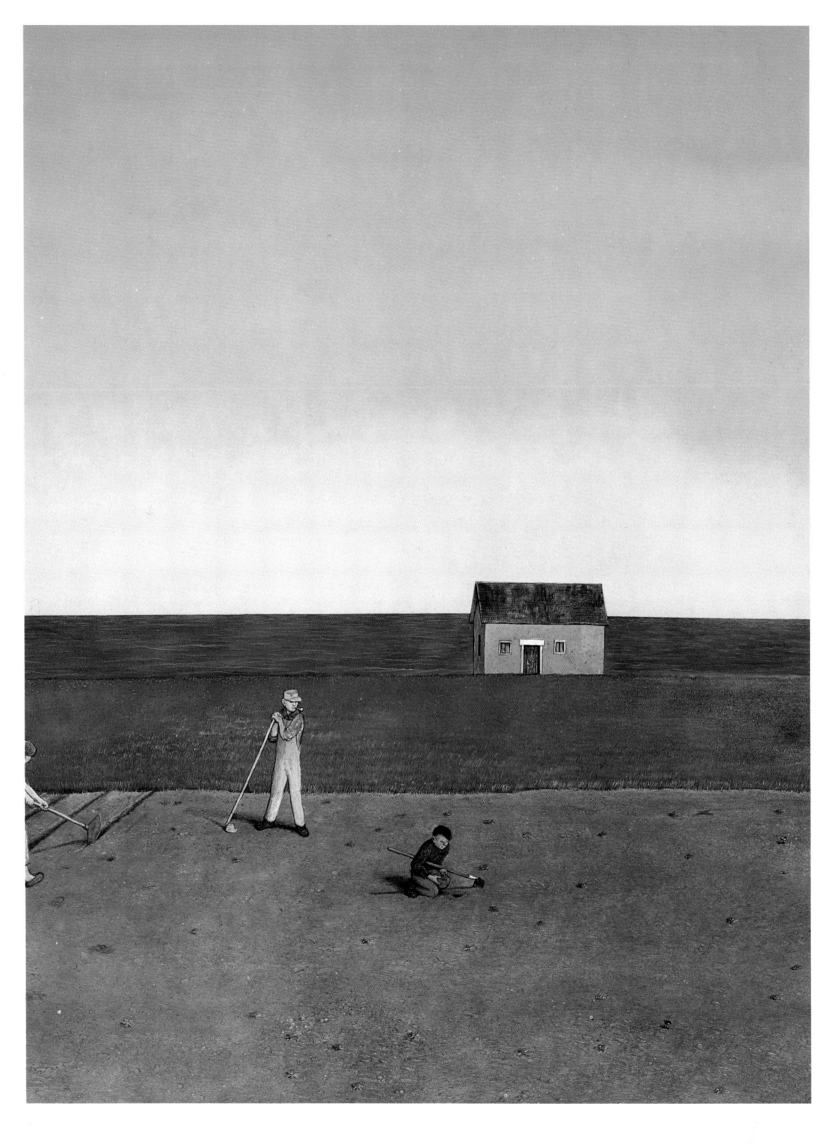

The sea is never far off in Prince Edward Island. Joe Maddix accompanied me on a tour of the coast just three miles from his farm. We drove over a section of road under construction where the freshly scarred earth revealed better than ever its red colour. On the sea's edge, there were small, oddly located, shingle-covered houses which Joe explained were fishermen's dwellings. Some of the houses sat in clusters, others stood alone, but none had any kind of windbreak to shelter them.

It is this stark, yet colourful, element of Prince Edward Island that I have tried to present in the painting of *Potato Farmers Admiring Baby Kildeers*: the red earth, the green fields, the blue sea and sky. The farmers have paused to watch the kildeers, a ground-nest bird I also knew well out West. Their pleasure in the birds is that hug-and-cuddle feeling one has toward nature's babies. Some kildeers have just hatched—little balls of fluff set high on legs thinner than toothpicks. A baby kildeer is a poor escape artist, tripping even over a blade of grass. The mother, meanwhile, tries to attract attention away from the baby by feigning a broken wing.

Joe also took me to a nearby lobster "factory" where I made the acquaintance of thousands of live lobsters being held in tanks. They are horrid big red relatives of the crayfish I dreaded stepping on in our swimming hole in Manitoba. I never could imagine people eating those red lobsters or even the Malpeque oysters for which Prince Edward Island is so famous.

Potato Planters Admiring Baby Kildeers 57

Quebec

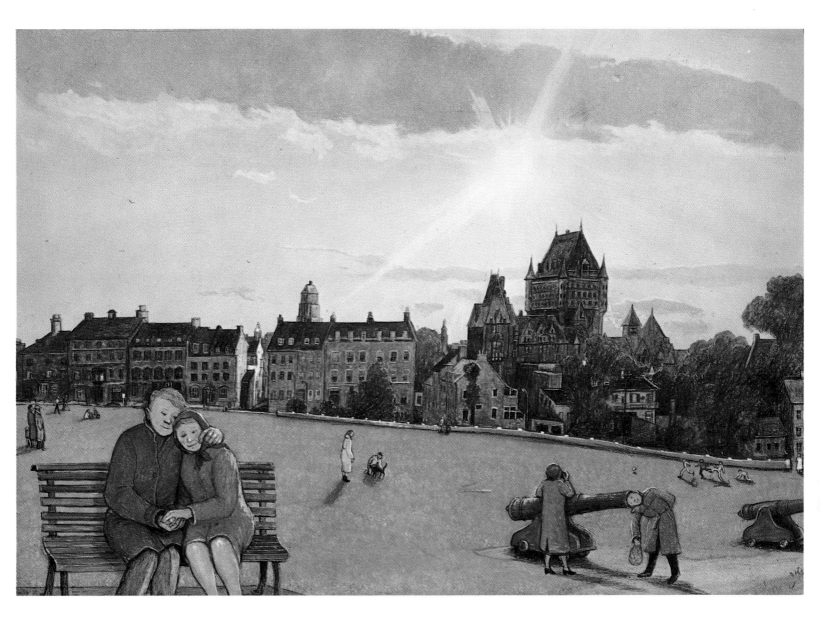

Honeymooners in Quebec City 61

My wife and I had our honeymoon in Quebec City in 1962 and stayed at the Château Frontenac, the tallest building in the painting. The hotel is named for the seventeenth century French count who proclaimed the city an impregnable fortress. It eventually fell to the English in an historic battle that ended French supremacy in North America. The bloody battle took place on the Plains of Abraham, lush green fields not far from where the lovers are sitting. The English forces, led by General Wolfe, scaled the steep cliffs of the city and defeated the French troops under Montcalm.

Now the cannon that once guarded the St. Lawrence are silent, objects of giddy honeymooning playfulness, or harmless props for snapshots in the family album. Quebec City has other personal and historical associations for us. My wife, Jean, was born in Quebec City. At the time her father had just left the British Army and, coming to Canada, found employment playing in the orchestra at the Château Frontenac. On the first day of our honeymoon, Jean and I, who in fact met through the Catholic Information Centre in Toronto, made a pilgrimage to the three-hundred-year-old church at Ste. Anne de Beaupré, just outside Quebec on the St. Lawrence River. We wanted to keep our minds on the sacramental nature of marriage rather than something which is solely a contractual arrangement. Actually the spiritual aspect does not detract from but enhances the joy of giving and receiving physical pleasure. I have tried to convey this private joy of sexuality in the painting where the warm colours and the closeness of the caressing couple on the bench represent the afterglow of physical satisfaction.

We loved Quebec City because of its French cooking and its quaintness. The language of Quebec is French, and is a reminder of Canada's "two solitudes" which continue to exist to

this day. While I felt it, it did not disturb me as something new and unexpected. I lived in a kind of isolation in my earlier years, having experienced a certain amount of prejudice or discrimination while growing up as the son of a Ukrainian immigrant in Manitoba. As a result, I feel a certain kinship with the French Canadian minority.

On our honeymoon Jean and I also visited Montreal, a city I know well. Later I was to hole up in Place Jacques Cartier in old Montreal from time to time to paint. The old quarter of the city has much the same charm as Quebec and from my room across from one of the big grain elevators, I could see the cargo ships plying the St. Lawrence Seaway.

I Married Jean Andrews

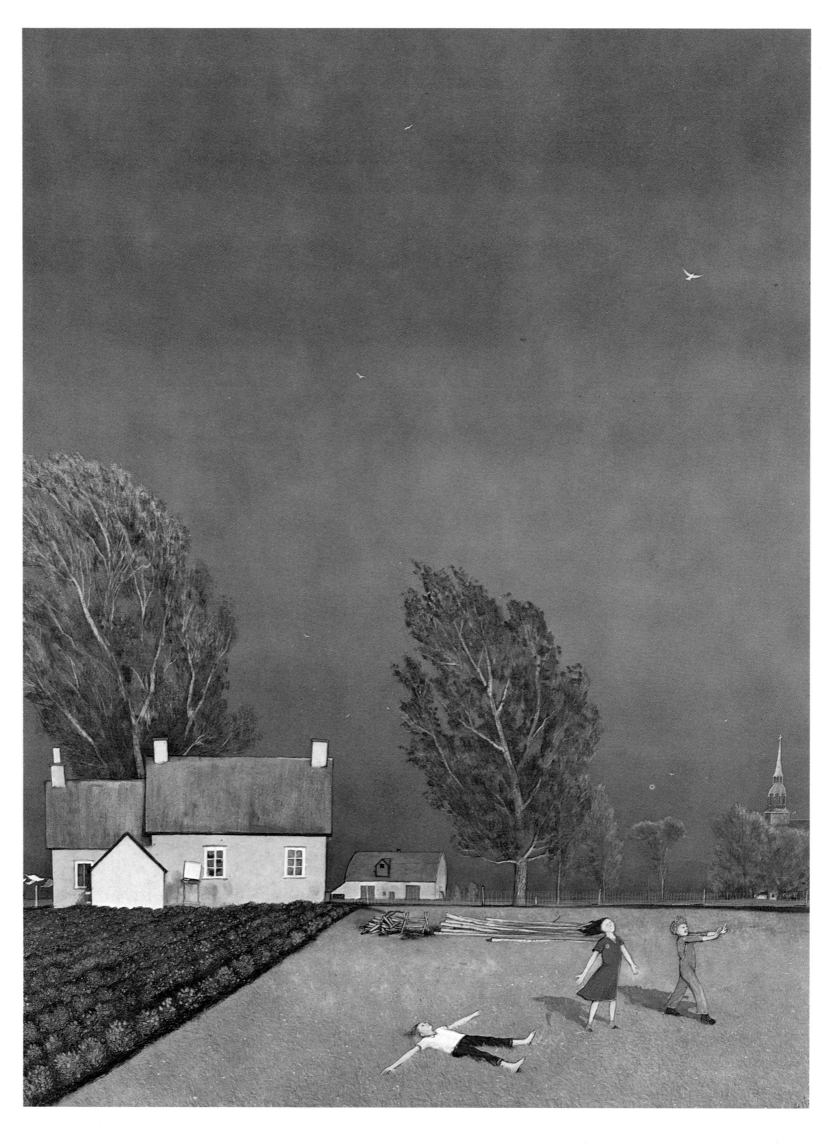

There is also something about the atmosphere of Quebec that has inspired its writers to weave tales of the supernatural or surreal. But to me a storm brooding over a quiet French Canadian farmhouse can be just as exciting. When I was a schoolboy, nature in paroxysm offered a trembling kind of ecstasy. It still happens once in a while, although it cannot be premeditated. The last big such orgy of mine was one whole day in Ireland. I recall an afternoon too in Edmonton, Alberta, when I was returning from work crossing a ball park. I saw a thundercloud approaching.

Like the boy on the ground in the painting I, too, lay on my back in the grass to enjoy the sky. Only my having to run for shelter from the actual downpour broke the spell. There was a delicious sense of complete abandon to nature, something like that experienced by William Wordsworth's boy skater on a still, starry night. In the Irish experience it was seeing the high wind that brought on the ecstasy, first in the writhing of a wheat field, then in the chopping wavelets on a water reservoir, and finally in the paroxysm of the low bushes clothing the valley of Glendaloch. I even did a dance on the road to let the wind spin me which way it wished.

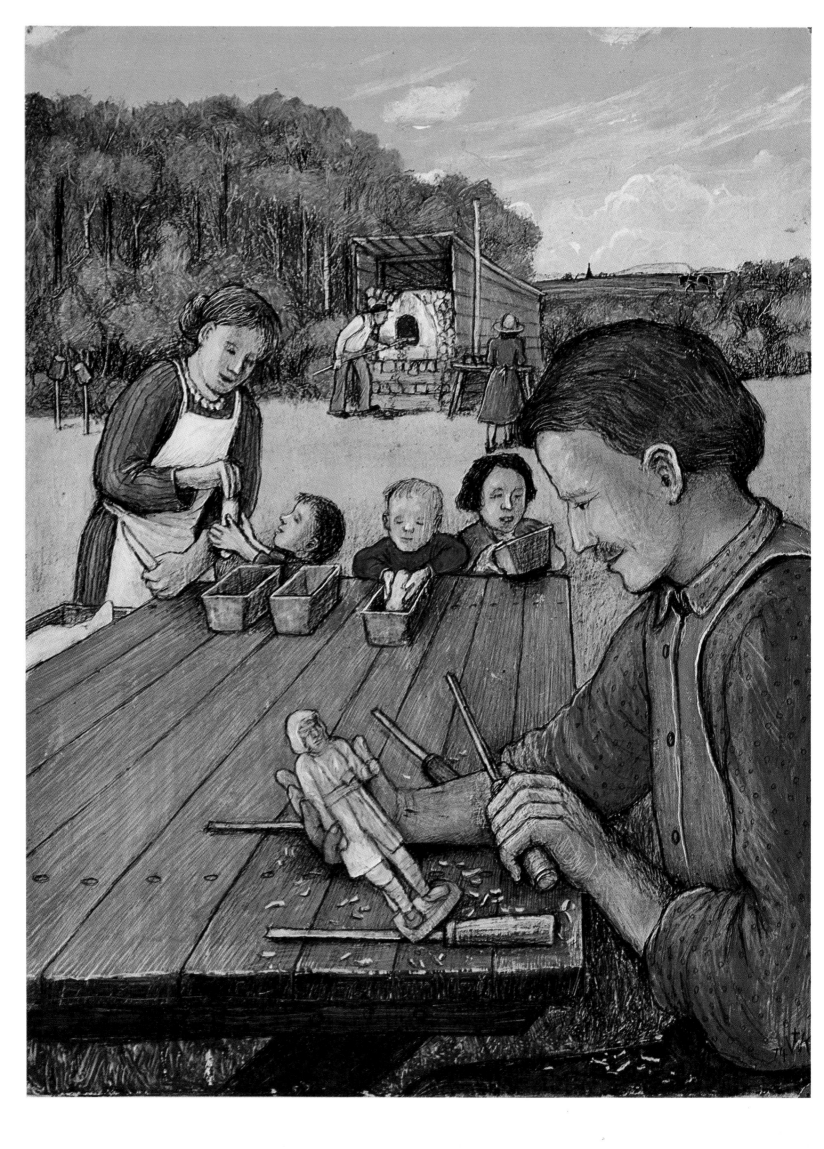

I first became aware of Quebec wood carving at a display of French-Canadian crafts in Montreal. This started my reverie or meditation on the joy a wood-carver might feel in his art. It is a blessed person who can provide for his family from the sale of creative work, as I know well from personal experience. The wood-carver I am thinking of is not a famous artist. He lives simply with his large family and all co-operate to make a go of it. They have had to knuckle down to make ends meet, but that can sometimes be a joy, as I have tried to show by the pleasure on the mother's face.

I did not actually see the oven depicted in the painting, in the Quebec countryside, but I know they are still around. I remember them in use in my own childhood in Alberta where Ukrainian pioneers built and used them. I was born into a large family—there were nine of us—and my mother baked bread often from flour bought in hundred-pound sacks. That has all changed now. We get our food pre-baked and pre-cooked in small pre-packaged quantities, artificially preserved.

Ontario

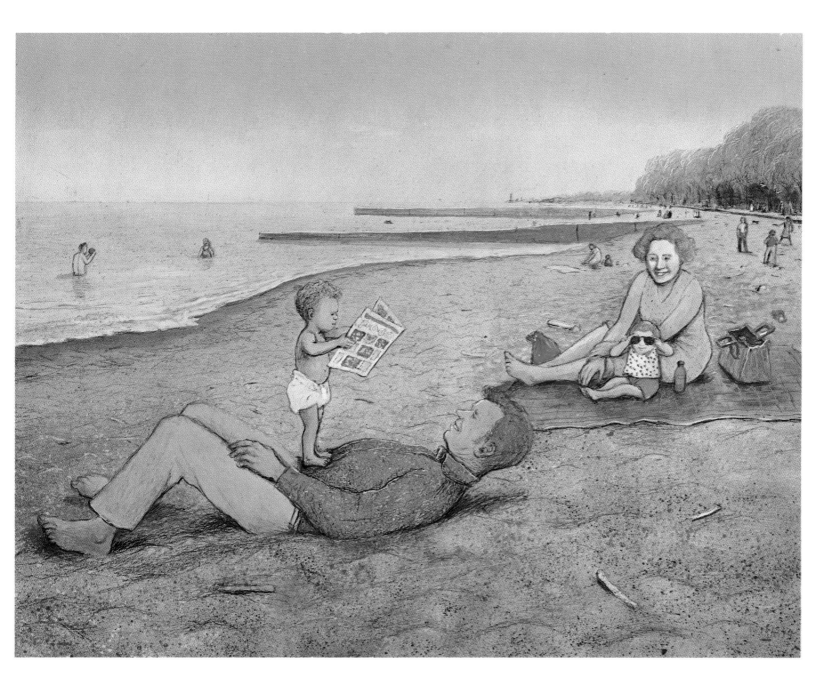

The Artist and His Family on Toronto's Beach 71

It is hard to believe that this resort scene is in the industrial and financial heart of a nation. Toronto is known for its office towers, its factories, its banks, and its stock exchange, not its beaches. Nevertheless, there we are—enjoying the sand and the sun at the foot of Balsam Avenue, only a few blocks from where we live. In the distance, on the western horizon are the faint outlines of downtown Toronto. It is only fifteen minutes away, but when you are sitting on that expanse of sand with the gigantic Lake Ontario stretched out before you, it feels like the city's core is miles away.

My wife and I like strolling the boardwalk there. That is my oldest boy, Stevie, on my stomach—pretending to be engrossed in Pogo. Children are such a joy when they put on adult airs. Cathy, beside my wife, is also pretending to be grown up. We now have two other children, Barbara and Tommy, and they too have their individual sweet and charming ways. It seems such a short time ago they were mere babes-in-arms. When one is happy, time flies.

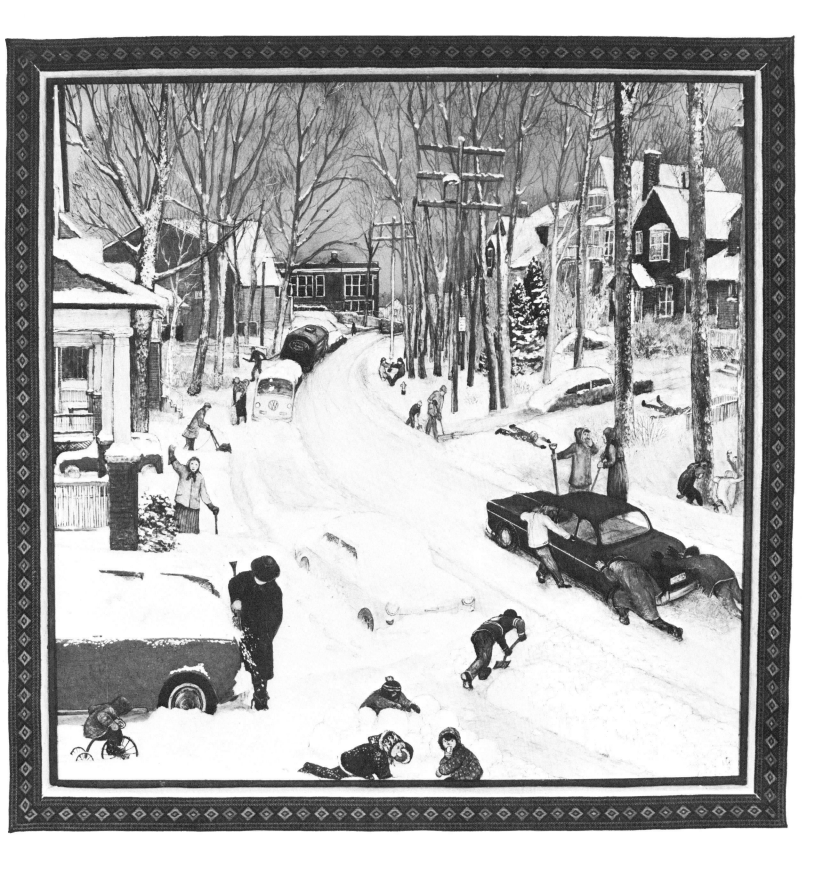

Balsam Avenue after Heavy Snow 73

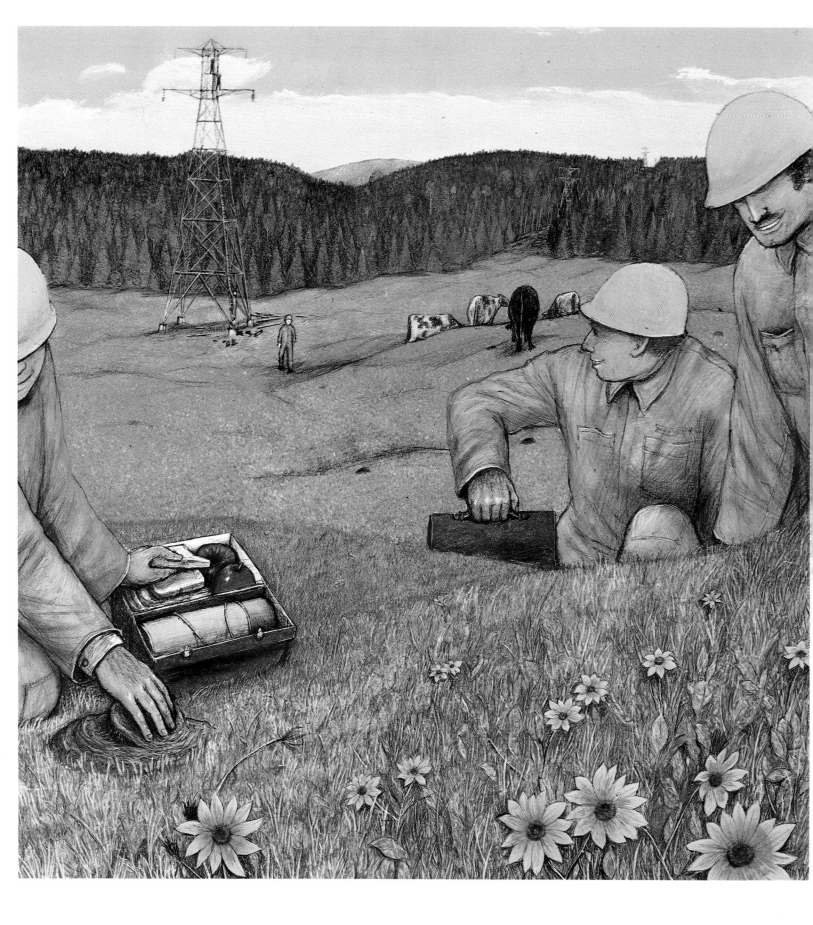

Terry Ryan's Lunch

My life with my family on Balsam Avenue, a quiet street with graceful trees and spacious houses, is very different from my youthful days as a lumberjack and construction worker when I was earning money to see me through school. Although I was agonizingly shy and timid, I immediately found myself drawn to the hearty camaraderie that prevailed among the men: the back-slapping, the yarn-telling and the practical jokes. Anyone who has lived and worked in close quarters with several other labourers will have a stack of stories of pranks and practical jokes. When I visited my friend Terry Ryan in Cape Dorset on Baffin Island, he recalled for me one particular summer in the rigorous northern area of Ontario where retreating glaciers have left small, rounded hills covered with a thin layer of soil suitable only for pasture land. Terry, a young art student earning money for his studies, worked on a construction crew putting through a hydro power line. They were a rough bunch of fellows and once playfully spread cow dung as filling in his sandwiches when he wasn't looking. Terry describes the incident affectionately, laughing as he tells the story. I know this idea of joy might seem odd or even repugnant to some people, but I can understand his pleasure in remembering it. The crude jokes are almost a rite of passage, a sign that you are a full-fledged member of the frater-nity. To a boy who is perhaps frightened, small in stature, and interested in such arcane pursuits as art, it is like a hearty, welcoming bear hug into the group. Anyway, this painting ran away with me: it insisted on being given expression.

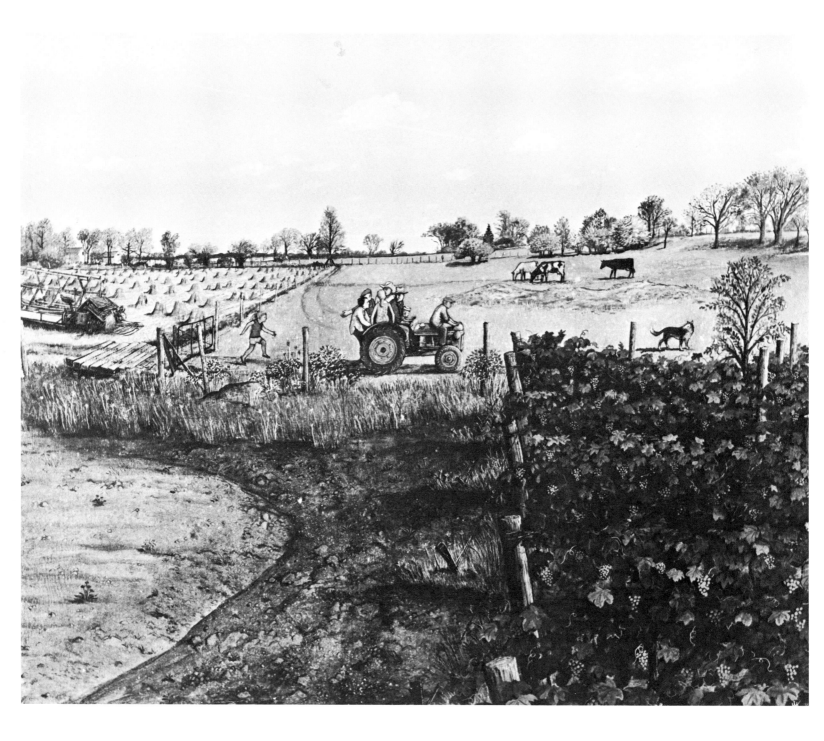

Fresh Start in Southern Ontario

Among the several things I have done in my life which met with my parents' disapproval was my conversion to Catholicism in 1957. Although they occasionally observed some of the Orthodox Church rituals, they were essentially not religious and could only understand my adherence to Catholicism in practical terms: a lifeline saving me from the violent despair and intense mental anguish which I had previously suffered. My mother was particularly vocal in expressing her view that religion killed joy.

Since my friends at the Catholic Information Centre occasionally planned a social evening, I asked my father if we could use the pasture land near the ponds for a party. In addition to providing a fine setting for the festivities, I knew it would be a good opportunity for my parents to meet my friends and hoped it might break down still further what was left of the barrier between me and my family. I planned an evening complete with games, a sing-song, and a skit with three "Indians" in feather bonnets. For the occasion, I built a wigwam and made seats of logs in a circle. I had also arranged for Jake Hoday, a jovial, hearty man to be master of ceremonies.

On the evening of the party, we all piled into a convoy of about a dozen cars and headed out of steamy Toronto toward Ontario's fruit belt to my father's farm near Vinemount which is only about twenty-five miles from Niagara Falls. The campfire blazed high and everyone performed. I even played my mouth organ, but it was hopelessly weak outdoors, and in the painting I replaced it with a guitar and accordion. We sang rousing songs, sandwiching in a few of our favourite hymns. Those marvellous people, laughing, singing, chatting with my parents and brothers and sisters, seemed to spill all over the yard. The two priests dressed in casual clothes joined in the fun. My mother helped

out with food and my father, feeling we needed more light than the campfire provided, rigged up the lantern.

It was in the best tradition of wiener roasts, with warmth, companionship, and music under the balmy summer night sky. But there was something else. I was finally able to convince my family that although people were very much involved in their religion, they could still enjoy the pleasures of this earth.

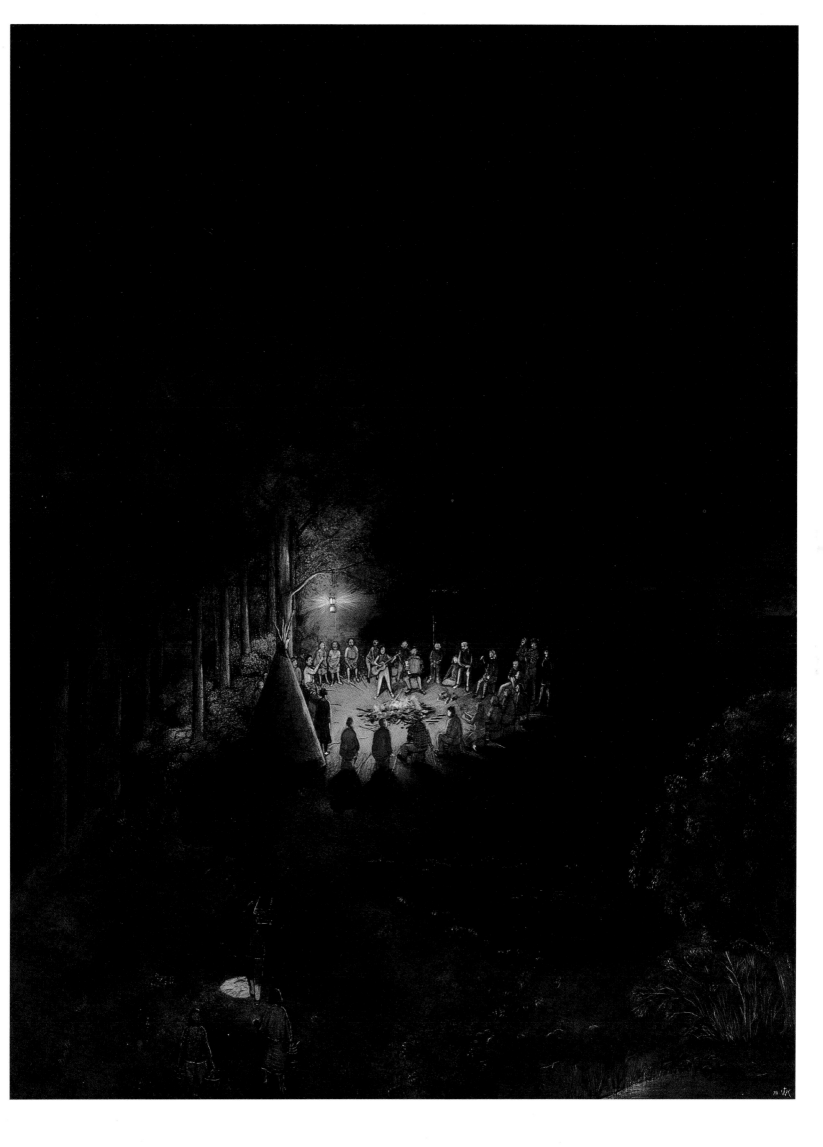

Manitoba

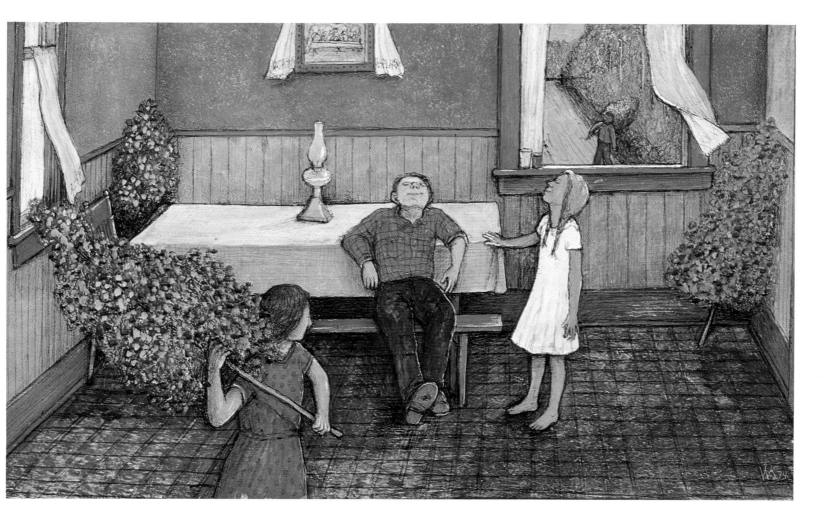

Manitoba, the eastern entrance to the vast prairie lands, is known for its wheat, its turbulent frontier days, and its bone-numbing winters. It is also known for its Ukrainian settlers. Travellers emerging from the rocky, wooded shores of Ontario's Lake Superior comment on the flat landscape dotted with grain elevators and the occasional onion dome of a Ukrainian church. My boyhood, from the time I was seven years old, was spent on a dairy farm nineteen miles north of the provincial capital of Winnipeg. Like other Ukrainian families, we continued to observe many of the Ukrainian customs. One ritual I remember poignantly is *Zelenyi Sviata* or Green Sunday, which welcomed spring after the long hard winter. Some people sprinkled their living-room floor with fresh-cut grass in honour of the season. In our house, my mother sent the children out into the bush next to the house to cut newly leafed poplar branches which we stood up in the corners of the house. The greenery was an enchanting change from the usual drabness of our big farm kitchen, and the sweet odour of drying leaves gave indefinable pleasure. Gentle breezes wafting through the open windows pushed the perfume of the leaves all through the house. Spring was now fully established and summer was approaching.

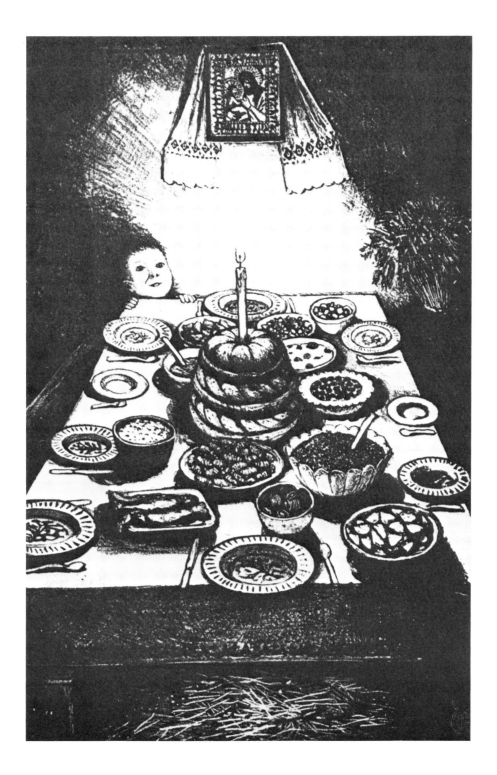

Ukrainian Christmas Eve Feast 85

Balmy Manitoba nights are rare. Its climate has been described as seven months of Arctic weather and five months of cold weather. My father used to say that one could not sleep on the grass as one could in Europe. I treasure the childhood memory of one particular hot night after a full moon had risen. My mother suggested that we children take off our clothes and run and dance in the farmyard. The grass was cool and soft underfoot and our large farmyard, with its buildings arranged in a circle, provided a natural arena for our performance. It was the sort of joyful experience usually snatched only once in a lifetime—a moment of carefree childhood as short-lived as the beauty of a butterfly.

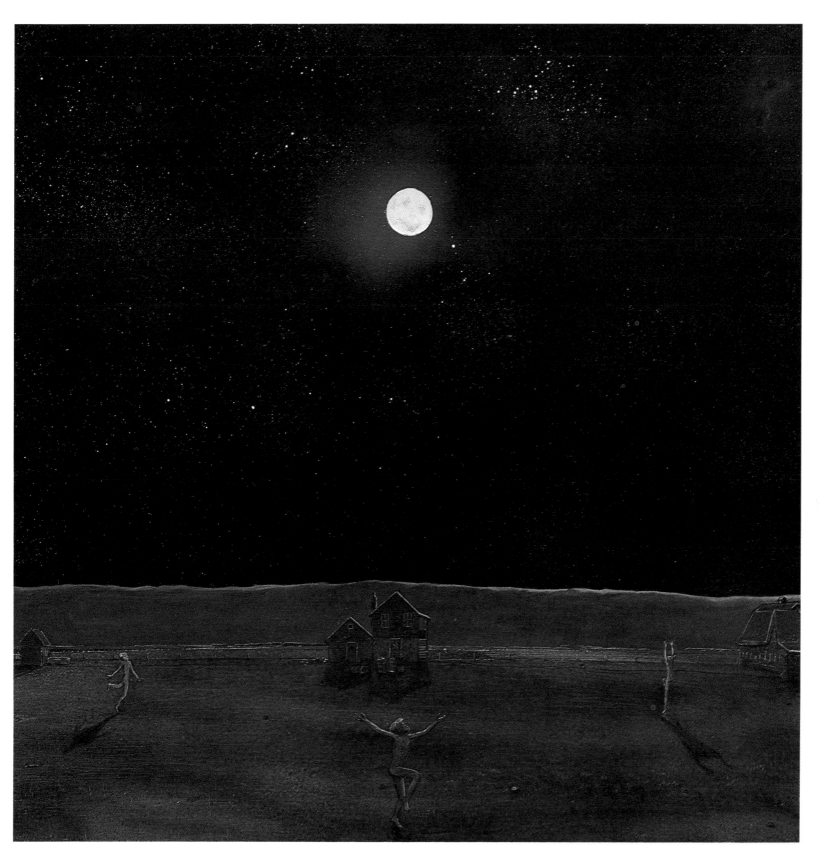

Midsummer Night Pixie Dance

To the outsider, the prairies might seem monotonous and drab, but as a child of the prairies I felt the thrill of living in an area where a part of Canadian history was made. Eastern Canada might seem to have a monopoly on the adventures of the voyageurs and the battles of the British and the French forces, but the stuff that Western movies are made of happened in our own next-door back yard. Ours was the country of the buffalo hunt, the Plains Indians, and the most recent pioneers. I was particularly interested in the Red River Settlement, a colony of Scots and Irish immigrants who established themselves on the shores of the Red River about 1812. They were caught in battles between the two fur-trading companies, one of which enlisted the aid of the métis (those of mixed French and Indian blood) in their cause. The colony was also afflicted by famine and by the flooding of the Red River. During the flood they retreated to Stony Mountain which we could see from our farm only three miles away.

One of the most fascinating heroes of that era was Louis Riel who led two rebellions of the métis in the struggle for self-government for his people. Educated and eloquent, he is one of the better-known figures in Canadian history.

From the scenic viewpoint, by far the most magnificent feature of the prairies is the panorama of the sky, awesomely grand and varied. When the weather forecast says scattered showers, you can actually see several showers taking place within the full circle of your vision. Even the wind is visible, as in W.O. Mitchell's wonderfully evocative book, *Who Has Seen the Wind*.

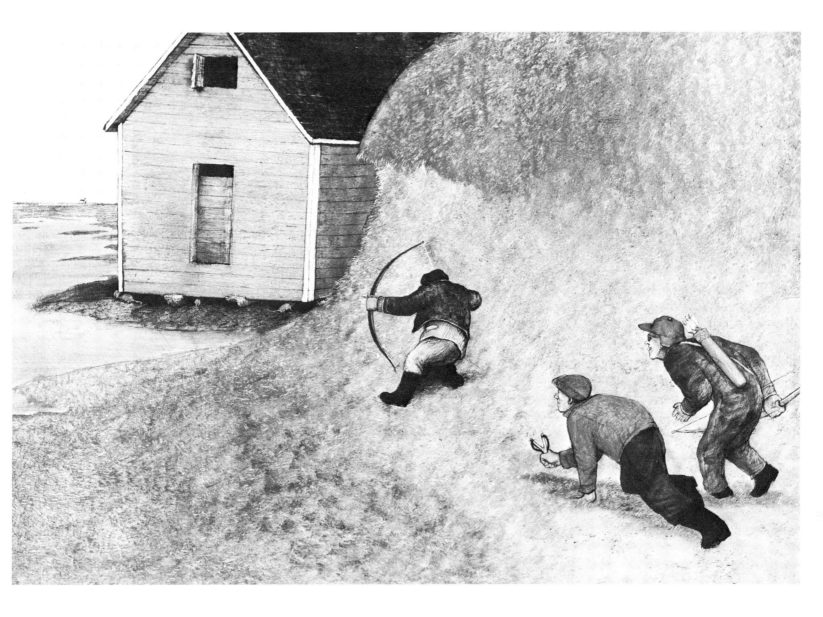

Ambush in Manitoba

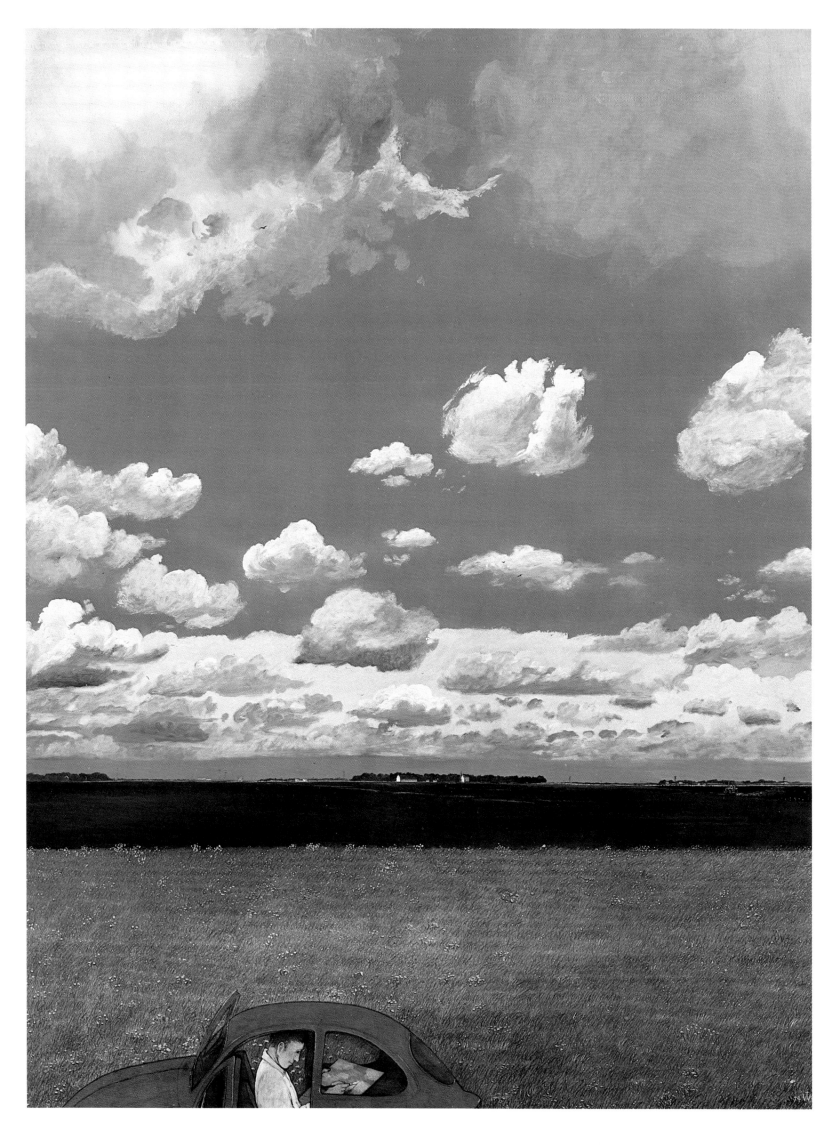

The land is so flat it is like being on an ocean. On a clear day from our farm we could see the smoke of Winnipeg rising nineteen miles to the south. When I returned to the area for a painting trip in 1963, I could see the top of the Winnipeg Commodity Exchange on the horizon. During that trip, I lived, ate, slept, and worked in a Volkswagen bug. I experienced one whole ecstatic afternoon and evening out on the bog east of our old farm. I photographed the skies all afternoon and when night fell worked on my paintings by the light in the car ceiling. It was completely dark outside until the moon rose. I still get a shiver of awe sometimes when I look at that series of photos in my album.

Saskatchewan

The Barn Dance

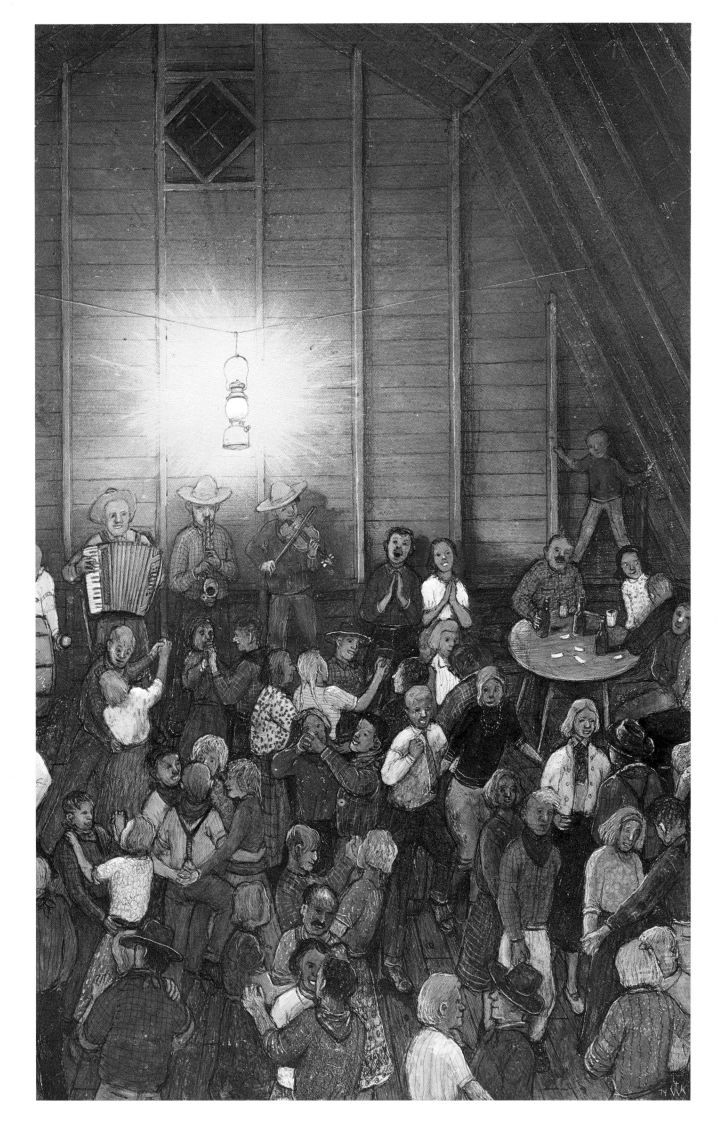

I lived on the prairies during the Depression but I did not realize it was a depression until I was sent to high school in Winnipeg in 1943 and the teachers told us about it. In retrospect, I suppose people were poor, but there were ways of making our own fun even in those hard times. Although I have never lived in Saskatchewan, I have travelled through the province enough to observe that the mode of living is very similar to Manitoba and Alberta. Like the other two provinces, its economy has long been based on agriculture with a heavy reliance on wheat. In the thirties, Saskatchewan suffered depression and drought, while today, with world-wide food shortages and the soaring price of wheat, it is booming.

Social life in what they called the "Dirty Thirties" was glorious to my boyish eyes. In the painting, *The Barn Dance*, I am the little boy standing high up in the corner, enthralled. Those country dances, which followed the same pattern in the Ukrainian settlements of Saskatchewan as they did in Manitoba, were exciting to watch. As a boy, I usually dreaded dancing and was content to stand on the sidelines, but I remember one party at the Tomyk's place where the adults cleared the floor to make room for the children to have a bash at the schottische. It is a dance where partners stand side by side in a circle holding each other with one hand by the waist, as I have shown it in the painting.

I recall a summer wedding party held in the hayloft of a Ukrainian neighbour. The young couple were married in a Ukrainian Church in Winnipeg and then drove back to the farm for the celebration. The bride wore the usual North American white wedding dress, but the party was Ukrainian. As each family of guests arrived the orchestra would switch to a special

song to mark their entrance. The bride and groom stood at the head table and the guests would approach in couples to wish them well. The man would deposit a gift of five dollars—a grand sum in those days—in a plate and would kiss the bride. They would then drink a toast with the newlyweds and perhaps eat a piece of cake. By the end of the evening the bride and groom were sometimes quite tipsy.

For a time our milkhouse, which had a long open room on the second floor, was used for barn dances. We lived in a dairying district and many of the barns had hay in the loft all year round, making them unusable as social centres, so other locations had to be found. I once went to a dance which the Icelandic community north of us held in a one-room schoolhouse. I had tagged along with my cousin Bill Budjak who played the accordion for them. To this day, the old-time tunes bring happiness to me and I mourn their passing.

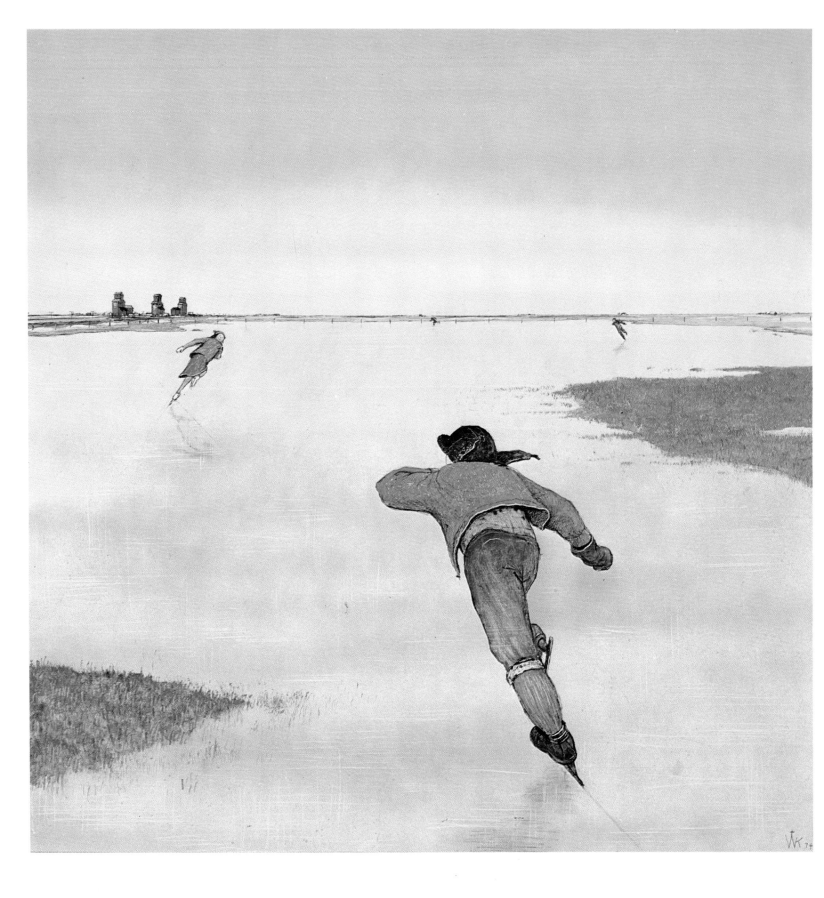

Skating on Spring Run-Off

The Saskatchewan prairie looks perfectly flat, especially south of Regina, but even there you find high and low spots. Spring run-off—the water from melted snow—collects in those low spots and refreezes in the chill of the nights. The ice may extend for a mile or more, paying no attention to artificial barriers like barbed wire fences. If there are few impediments, it forms one great long skating rink and makes you feel as though you have wings on your heels. The bog to the east of our farm had no fences whatever and when it froze over we could skate for miles. Ordinarily prairie distances frightened us. It took a lot of effort to cover them by foot or even on our bikes. But suddenly there, on that run-off ice, with just a few deft strokes of our feet, we skimmed over the prairie surface with breath-taking ease. Being released from that tyranny of distances was exhilarating. There was an added thrill if the ice was thin: you gambled and won, over and over again, as you heard the ice ping and crack behind your heels.

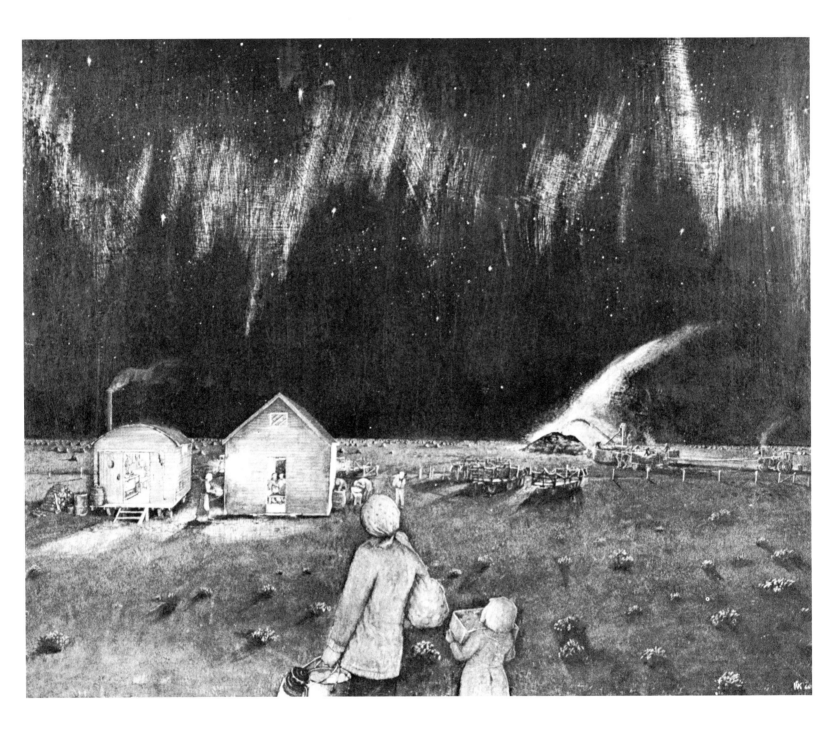

Women Feeding Threshing Gang

The harvest can be a time of tension or exhilaration. Between planting and the delivery of the grain to the elevators, any number of disasters can befall the crop. In Saskatchewan, where the crop is wheat and the mainstay of the economy, it is especially vital. The wheat harvest is also important in world terms: it is the largest wheat producer of Canada's three prairie provinces and Canada, as an exporter of wheat, is second only to the United States.

The farmer in my painting is savouring the joys of a bumper harvest. Now farmers are often grumblers and pessimists. My father, for instance, would not openly express happiness over a sizeable crop but occasionally I could detect signs of low-key enthusiasm. There are always worries about the weather. If yields are high, then the price may drop. Nevertheless, I have depicted the Saskatchewan farmer taking obvious pleasure in the outcome of his work as he emerges from one of his steel granaries filled to overflowing while the combines are still active in the field.

There are several stages in bringing in the wheat. Work starts in the morning after the sun has burned the dew off the ground. The combines do several jobs mechanically, from loading the grain into the trucks that drive alongside, to delivering it to the steel bins on the farmer's property. The grain may be taken almost immediately to the elevators along the rail tracks, for transport to the shipping ports on Hudson's Bay, the Great Lakes, or the Pacific coast. Sometimes the farmer may delay delivering grain to the elevators knowing that the prices will rise after the harvest.

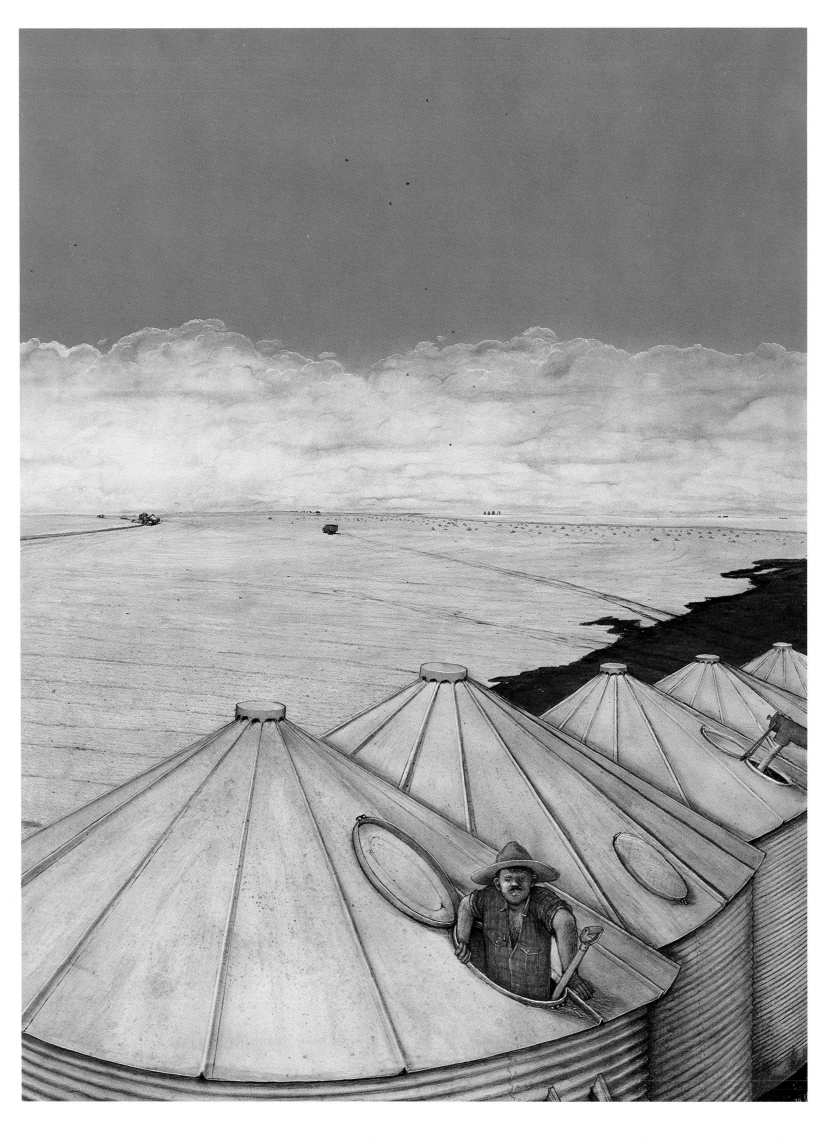

When I helped my father harvest wheat on our dairy farm in Manitoba, we did not have new-fangled combines. They were on the market but people were still recovering from the Depression. There was little money for modern equipment. Besides, we only harvested one section (one square mile or 640 acres) while the Saskatchewan farmer in the painting obviously has several sections. We used a binder which cuts the grain, binds it into sheaves, carries them, and then drops them into piles in rows suitable for stooking. Stooking, a lovely word, is a way of piling the sheaves so that the grain will dry for threshing. If it is not dry, the kernels may mould or sprout and much will be lost.

In the painting I have shown a patch of burnt stubble, but the burning is done well after the harvest. It nourishes the soil in preparation for another season and hopes of another bumper harvest.

A Bumper Harvest

Alberta

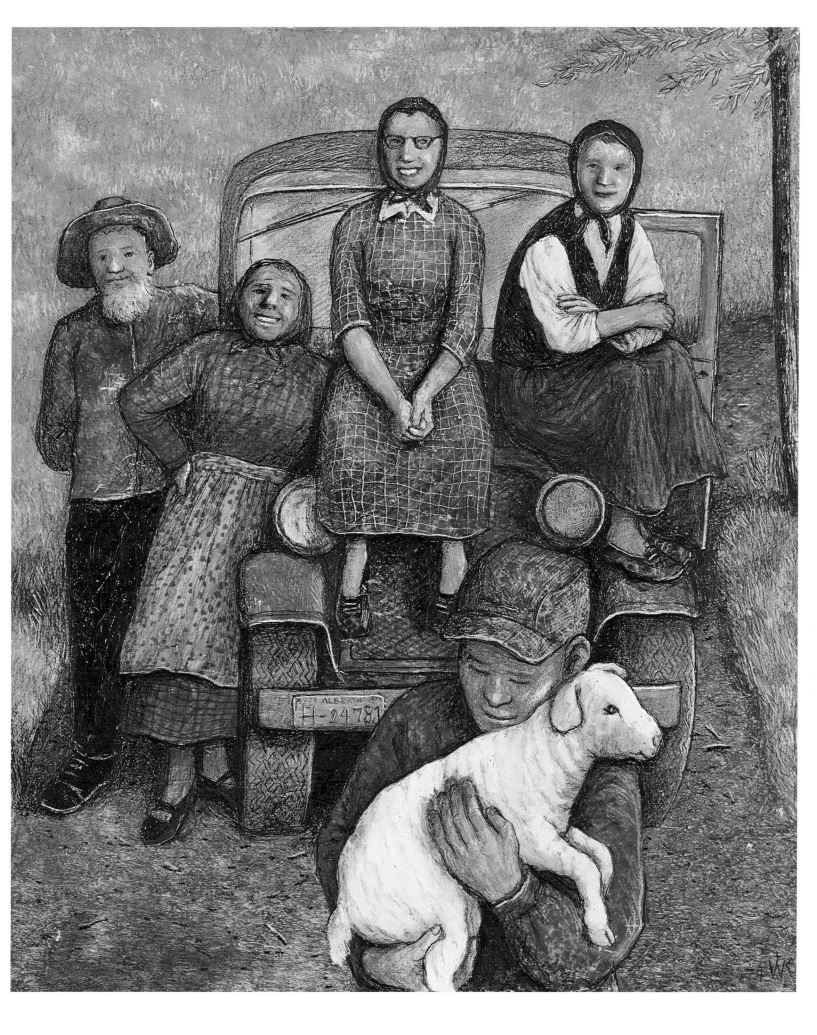

Hutterites Happy with Good Day's Work Done 107

It was religious prejudice and persecution that drove the Hutterites from Europe to the Great Plains of North America in search of farm land and peace to worship God in their own way. There are now more than a hundred Hutterite settlements on the Canadian prairies and, like the Old Order Amish and Mennonites whom I knew in Manitoba and Ontario, they lead a strictly disciplined communal life. Isolating themselves from the sinister influences of the world beyond their farms, they eschew modern luxuries and dress in Old World clothing. Their hard work and spartan living provide them with a large cash surplus and the ability to buy up large tracts of land. In some areas this has angered local farmers who sometimes seek measures to prevent Hutterite farms from expanding.

Occasionally young people leave the community but many return again. I read of one young Hutterite in the United States who left the colony for several years. He joined the navy, travelled the world, and returned, saying, "I found that this is the only way for me to live."

One might think that such a strict religious life would make for dour personalities. But these happy, serene faces indicate the joy to be found in an honest day's work close to the land and a life devoted to God and one's neighbours.

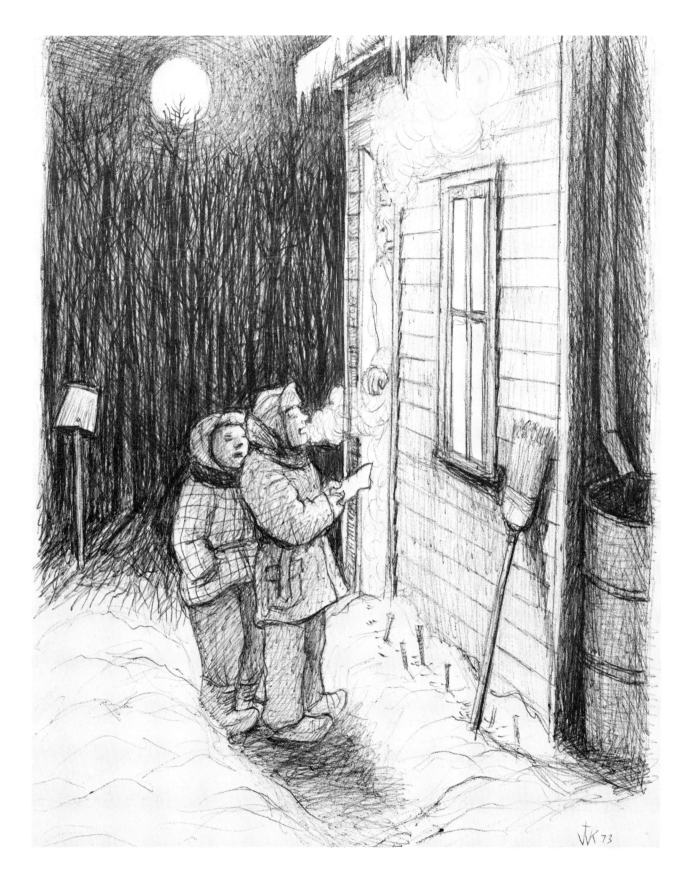

Ukrainian Carolling

In 1973 I visited my father's brother George who lives on the Alberta-British Columbia border in the Peace River district where the Rocky Mountains meet the plains. It is just about the northernmost limit of settlement in that part of the country. It still has a frontier atmosphere. The Peace River runs through a deep canyon about a mile wide and the south bank is much more developed than the north. Crossing it by car ferry was a harrowing experience, especially the drive up the side of the north bank after a rain, along a steep, twisting, unpaved road.

Uncle George came to Canada just before World War II and spent a year on my father's farm in Manitoba. Then he headed further west to the Peace River district. In the 1940's they were just opening up the country and land grants were available to settlers. He started from scratch, clearing the land by "breaking" it, ploughing it for the first time. He grew grain and raised livestock. But in recent years it has become more and more of a struggle for the small farmers to remain financially solvent. Moreover, Uncle George's farm is so far north that every few years an early frost can wipe out his entire crop. So he now works at a sawmill just over the British Columbia border in Dawson Creek, where the Alaska Highway begins. His son Metro is a rugged entrepreneur. He farms, acts as a guide for moose hunters, and owns his own "cat" which he operates and hires out to oil companies. He cleared the bush for the drilling site shown in my picture and I have painted him standing on the seat of his caterpillar to get a better view of the gusher while the other workers dance a jig in exultation.

Oil Strike in Peace River Country

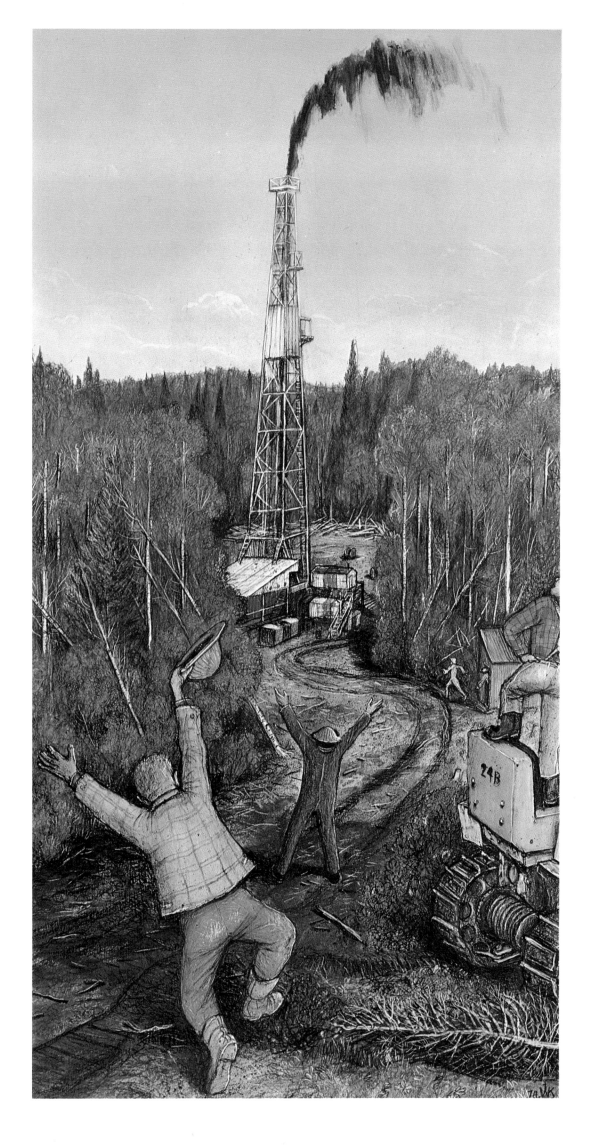

My mother was born of Ukrainian parents on a farm in Alberta. Most of her nine brothers and sisters live in or near Edmonton, making for a host of aunts, uncles, and cousins to visit on my trips west. The majority of my relatives continue to attend the Ukrainian Orthodox Church but, like other minority ethnic or religious groups who have been in North America for three generations, they are caught in the midst of a cultural transition which becomes more difficult with each generation. There is often a conflict: Should religious services, for example, be conducted in English or Ukrainian? Should they be shortened from three hours to a length more in keeping with North American patterns of worship? And so forth.

When my father sent me and my brother John to high school in Winnipeg, we also went to Ukrainian night school. In the process of retaining our heritage, we became better acquainted with the beauty of Ukrainian carols. At Christmas, in accordance with custom, we were divided into groups and sent out carolling. The boys in the painting are a group of Ukrainian carollers crossing an Edmonton park while the lights of the city glow softly in the background. They carry the traditional star of Bethlehem before them.

I recall on the first of the three days of Ukrainian Christmas, we were still somewhat ill at ease singing right in somebody's home, so there was a tendency to burst forth in full voice outside, in the middle of the park, well away from the public. In this picture I have also imagined that in a kibitzing spirit one of the boys let out a whoop as he passed a snow fence and ran a stick across the fence slats pretending he was playing a giant cymbaly, or dulcimer.

Young Ukrainian Church Carollers

British Columbia

Excitement of First Heavy Snow

Many people outside Canada believe that our winters offer only an icy bleakness. But sometimes the snow has a warming, clinging effect, making a wonderland out of the trees and landscape. I remember such a snowfall in November, 1950, when I was passing through the mining town of Fernie in British Columbia. I was hitchhiking to Mexico to continue my art studies there and had managed to get several rides west and southward from Calgary, Alberta. The ride into Fernie was in the back of a pickup truck and perhaps that is the reason I will always remember that part of British Columbia. I nearly froze in the back of that truck. Mile after mile I could hear the whine of the tires and the rattle of the gate chains. I tried to curl into as tight a bundle as possible to stop my teeth from chattering. The ordeal ended when I stumbled into a lighted, old, blessedly warm hotel. A group of Italian-Canadian miners in the lobby stared inquisitively at me. The next day, a couple who were hunting mountain goats, gave me a ride during a thick, white snowfall that seemed to warm and smooth the contours of the land. Children of course love such a snowfall which is ideal for their games. They try to catch it with open mouths, mold it, roll in it, or simply luxuriate in it. Writer Barry Callaghan sees this painting as an expression of joyous worship—a kind of cathedral in the woods.

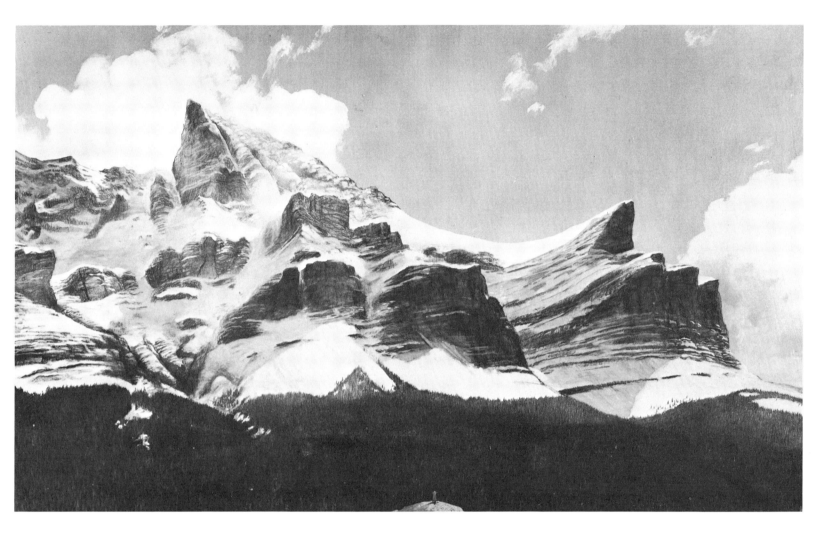

Divine Symphony of Forest Rock and Snow

This painting may look like fantasy, but I have it on good authority from a forest ranger in British Columbia that it did happen. Like most animals, these sometimes fierce and deadly beasts also have their playful side. To the forest ranger the playfulness or humour of the grizzly bear is an indication of its intelligence. He had happened upon a grizzly sliding down a glacier and stayed to watch from a safe distance. When the bear reached bottom, it stood up, looked back to where it had come from, scratched its head, and then purposefully climbed back up the glacier to slide down again.

Grizzly Sliding down Glacier

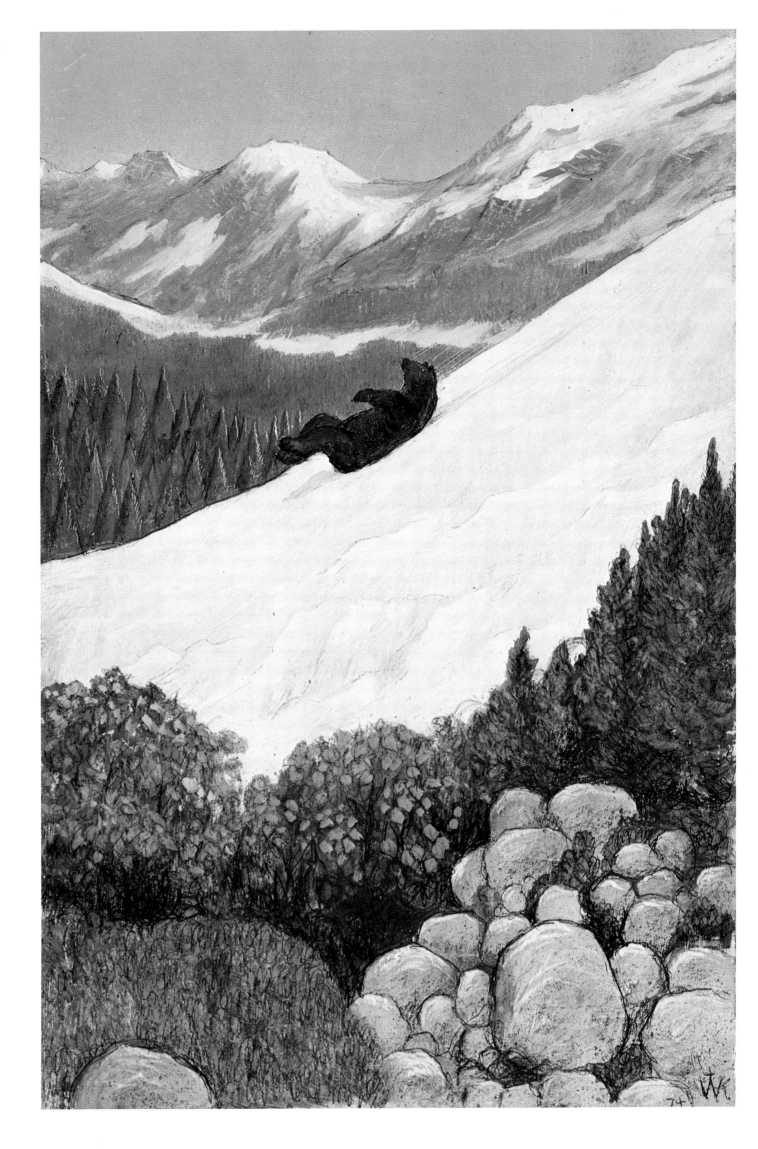

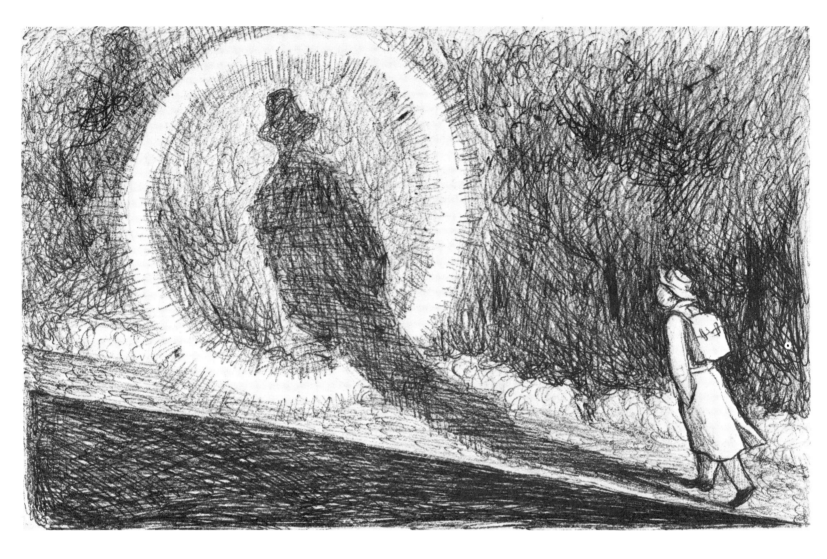

I Saw Eternity the Other Night

"Those far away places
with the strange sounding names
which keep calling, calling me."

This is a reverie of youth: a longing for the independence of young manhood and dreams of adventure. The poignancy of such yearnings can be heightened even more by sounds—the whistle of a freight train or the blast of a foghorn. It is a time when all things seem possible. How well I remember those passions for escape. In order to get to Mexico to continue my art studies, I had to hitchhike and that meant somehow overcoming my shyness and my reticence to approach strangers. At times when fear of asking favours proved stronger than my determination to reach my destination, I walked, hoping someone would pick me up out of compassion. I remember one such walking marathon between Edmonton and Calgary. Unable to bring myself to hitchhike, I found myself walking mile after mile until the moon had come up cold, like half a white wafer resting on clouds. I later did a lithograph of this, showing only my feet, to convey the sensation of such exhaustion that one's entire being feels like nothing but feet.

Later when I was desperate to get to Europe for the first time, I settled for a cabin on a freighter at the rock bottom rate of $112.00 so I could stretch my stake as far as possible. By now I have crossed the Atlantic many times—four of those by ship— and have visited Western Europe, Africa, the Middle East, India, Hong Kong, and the Soviet Union. I will continue to travel westward too. I sympathize with the youth sitting on Canada's westmost limits as the haunting, poignant call of ocean-ships' horns draws him into a reverie of far away places.

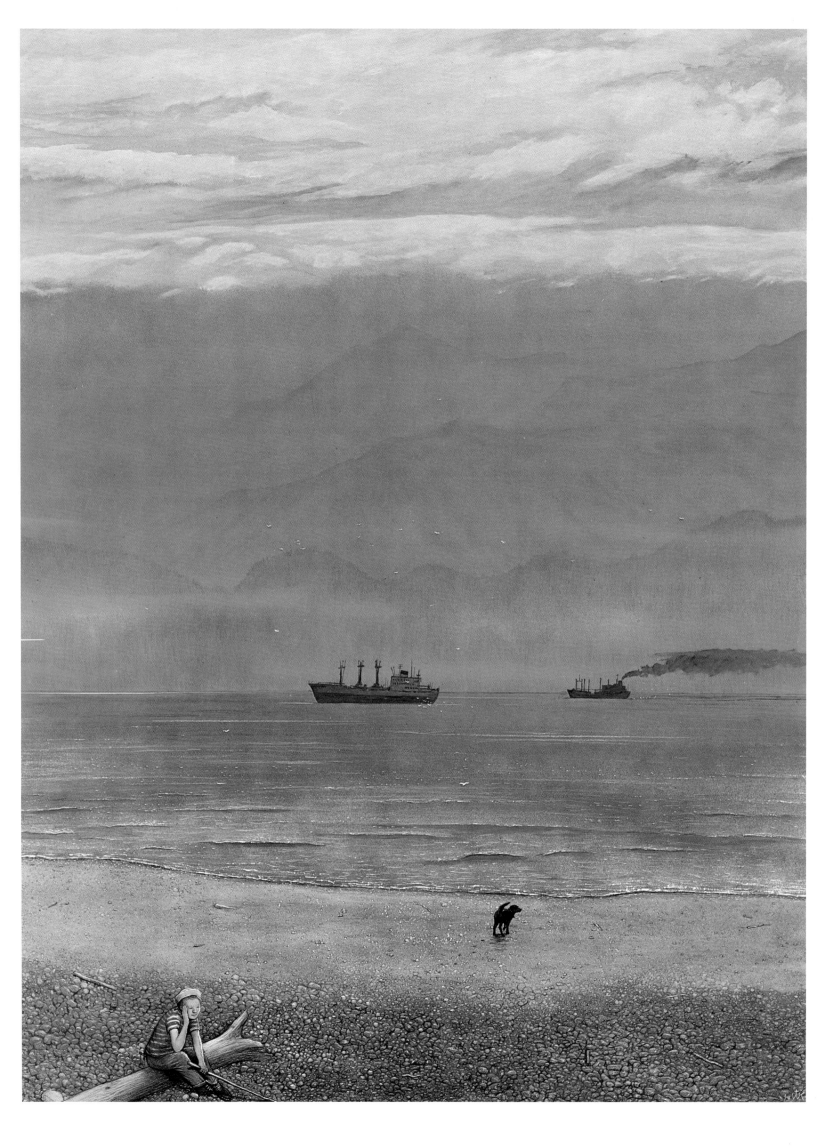

There is nothing wrong with dreaming and searching as long as one does not make my mistake of long ago. I had imagined that happiness was to be found "somewhere way out there." But it isn't. Paradoxically, it is within oneself, and at the same time beyond all boundaries. It is in God.

The works of art illustrated in this book
are from the following collections:

15
Fish Fry at Middle Cove
Mixed media 1974 24″ x 38″
Mr. Nathan Isaacs
Downsview, Ontario

17
Newfie Jokes
Mixed media 1974 48″ x 36″
Mr. Michael Phillips
Toronto, Ontario

20
Newfie Woodsman Doffing Rainwear
Mixed media 1974 11″ x 9″
Private Collection

25
Cowherd Enjoying Adventure Thriller
Mixed media 1974 9″ x 7″
Private Collection

28
Atlantic Lobster Fisherman
Mixed media 1974 48″ x 36″
Helen Graham Friedson
Mississauga, Ontario

32
A Neighbourly Visit
Mixed media 1974 24″ x 24″
Private Collection

37
New Brunswick Potato Diggers Enjoying
Autumn Colour
Mixed media 1974 48″ x 36″
Mr. and Mrs. M. Blustein
Toronto, Ontario

40
Bûcheron Enjoying Breakfast
Mixed media 1974 10″ x 9″
Private Collection

44
Spring on the Saint John River at Fredericton
Mixed media 1974 25″ x 24″
Mr. and Mrs. A. Wandich
Mississauga, Ontario

49
Pastoral Symphony
Mixed media 1974 25″ x 39″
Private Collection

53
Homecoming to P.E.I.
Mixed media 1974 13″ x 9″
Mr. and Mrs. Emmett Maddix
Toronto, Ontario

56
Potato Planters Admiring Baby Kildeers
Mixed media 1974 48″ x 36″
Private Collection

61
Honeymooners in Quebec City
Mixed media 1974 16″ x 23″
Mr. and Mrs. Bruce Hodgson
Toronto, Ontario

64
Quebec Farm Children in Nature Ecstasy
Mixed media 1974 48″ x 36″
The Isaacs Gallery
Toronto, Ontario

66
The Wood-carver's Family
Mixed media 1974 13″ x 10″
Private Collection

71
The Artist and His Family on Toronto's
Beach
Mixed media 1974 13″ x 10″
Mr. Peter F. Oliphant
Toronto, Ontario

74
Terry Ryan's Lunch
Mixed media 1974 24″ x 23″
Private Collection

79
Wiener Roast on My Father's Farm
Mixed media 1974 48″ x 36″
Private Collection

83
Zelenyi Sviata
Mixed media 1974 7″ x 12″
Mr. Charles McFaddin
Toronto, Ontario

87
Midsummer Night Pixie Dance
Mixed media 1974 23″ x 23″
The Isaacs Gallery
Toronto, Ontario

90
The Painter
Mixed media 1974 48″ x 36″
The Isaacs Gallery
Toronto, Ontario

95
The Barn Dance
Mixed media 1974 23″ x 14½″
Mr. and Mrs. J.A.T. Lewis
Toronto, Ontario

98
Skating on Spring Run-Off
Mixed media 1974 23″ x 23″
Private Collection

102
A Bumper Harvest
Mixed media 1974 48″ x 36″
The Isaacs Gallery
Toronto, Ontario

107
Hutterites Happy with Good Day's
Work Done
Mixed media 1974 14″ x 12″
Mr. and Mrs. R.T. Bies
Etobicoke, Ontario

111
Oil Strike in Peace River Country
Mixed media 1974 23″ x 12″
Mr. R.A.N. Bonnycastle
Calgary, Alberta

113
Young Ukrainian Church Carollers
Mixed media 1974 48″ x 36″
Northern and Central Gas
Corporation Limited, Toronto,
Ontario

117
Excitement of First Heavy Snow
Mixed media 1974 38″ x 23″
Private Collection

121
Grizzly Sliding down Glacier
Mixed media 1974 11″ x 7″
Private Collection

124
Dream of Far Away Places
Mixed media 1974 48″ x 36″
Mr. and Mrs. Irving Ungerman
Toronto, Ontario

Photography by Hans Geerling
Typesetting by Editorial Composition Services
Colour separations by Herzig Somerville Limited
Renaissance paper by The Rolland Paper Co. Limited
Printed and bound by The Hunter Rose Company

Project supervision by Glenn Edward Witmer